Pastel Moods

Marioly Vazquez

COLLECTIVE SHORTS
by NHP PUBLISHING

Mood colours

C20 M0 Y10 K0 C0 M18 Y8 K0 C0 M4 Y22 K0

After graduating a few years ago, someone told me: "Right now your life is a white canvas. You have to decide how to paint it with your choice of colour. You have endless possibilities in the artwork that is your life."

These words inspired me to open my eyes wider by paying attention to details, textures and colours. Having grown up in Mexico, I was always surrounded by colour. Colour is an important element in my culture, so it has always surrounded me.

Photography became a way to preserve those colours and keep them palpable in my memory. I wanted to capture the beautiful colours, textures and scenes I encountered in my daily life. Over time I became more contemplative, and wanted to convey a feeling of peace and tranquillity through my photos, one that will fill people's hearts with joy through visual meditations.

Pastel hues and soft tones immediately resonated with me. Their softness and subtlety allowed me to portray feminine, cheerful and whimsical images. They became the most predominant element in my photography, and since then, no matter where I travel, I am constantly searching for beauty through pastel colours.

I hope this book opens your eyes and fills your heart with light, a light that will illuminate the beauty that surrounds us.

Blue skies have become a metaphor for bright futures – distant and present. In art, in film, in literature and in life, blue skies signify vast possibilities, new beginnings, and an inexplicable sense of harmony that fills our hearts and bursts from our chests, into the world. Our horizon broadens as we sink our toes into the wet sands of the seaside. It shrinks as we stop to smell the blue tinted flowers and embrace the tranquillity of finding ourselves in the here and in the now.

We are drawn to houses and doors bathed in hues of blue, confident about the quiet world that awaits us within. We connect to the stillness these spaces embody, the consonance appeasing our pacing minds and tired souls.
We wrap our bodies in denim, sapphire and midnight blue, honing the sentiments our wardrobe emits, matching our interior landscapes with our exterior portrait.

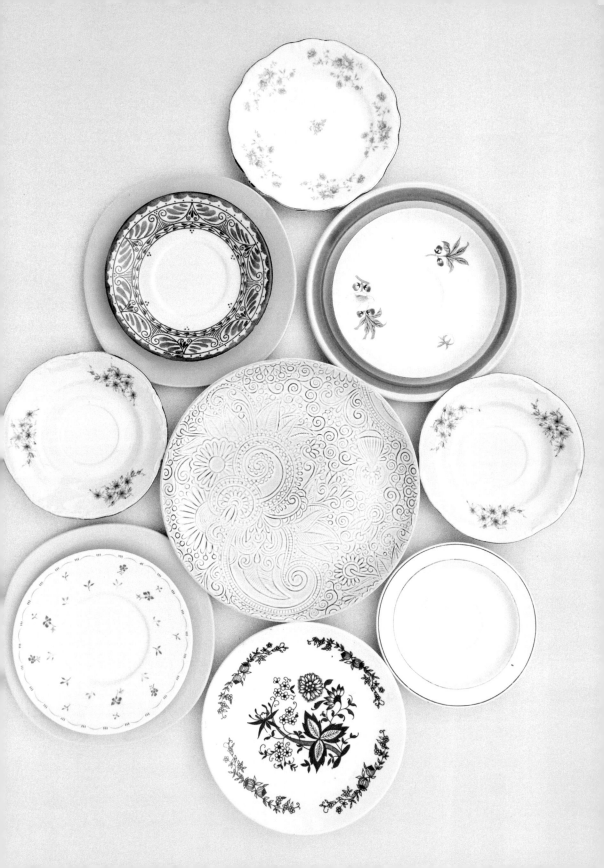

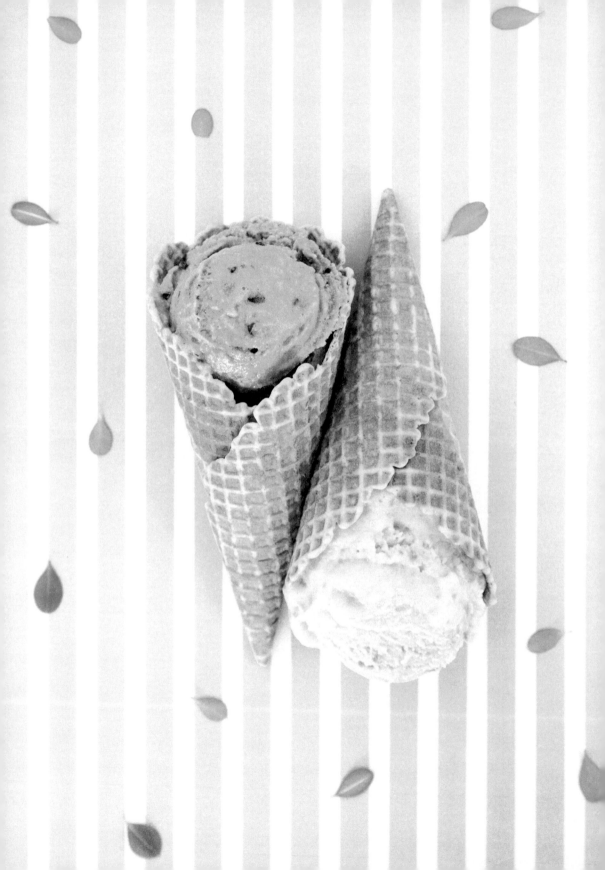

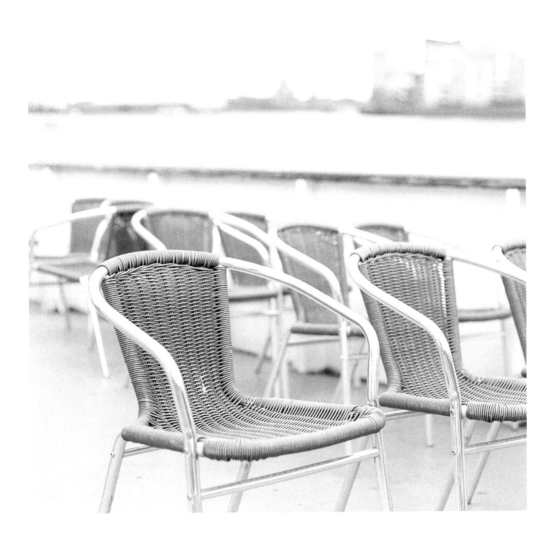

C5 M15 Y9 K0 C0 M10 Y17 K0 C27 M11 Y5 K0

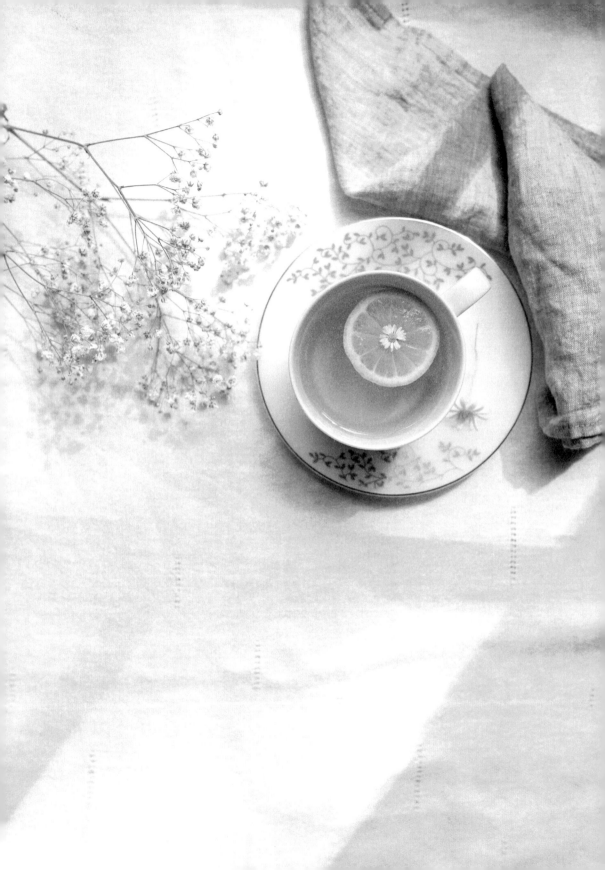

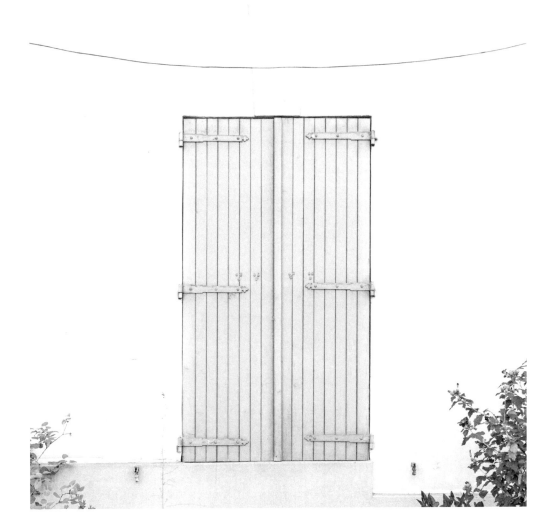

C18 M9 Y2 K0 C4 M8 Y8 K0

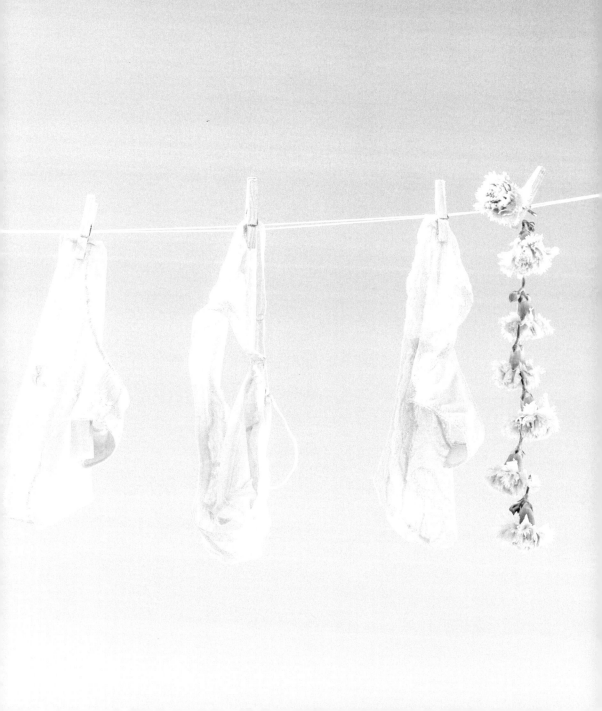

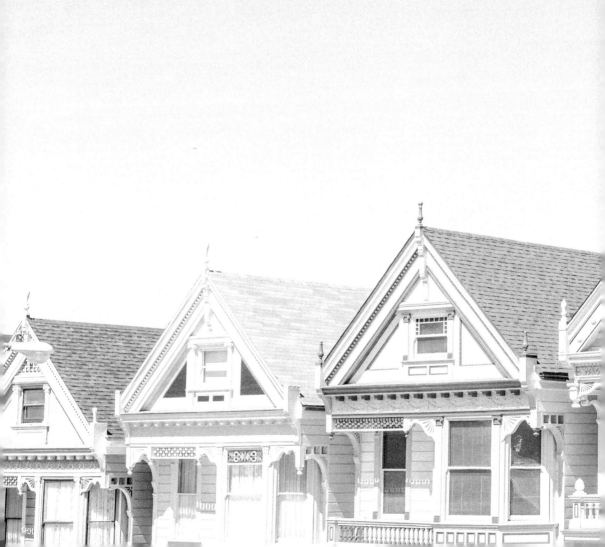

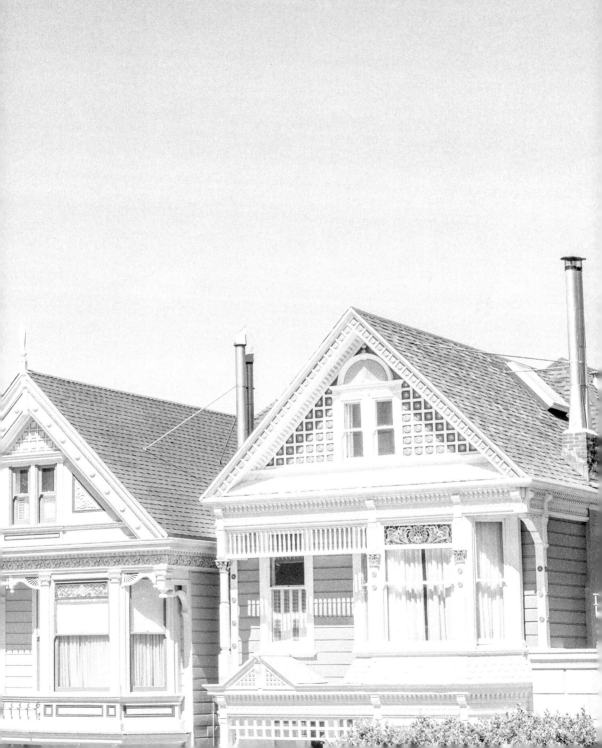

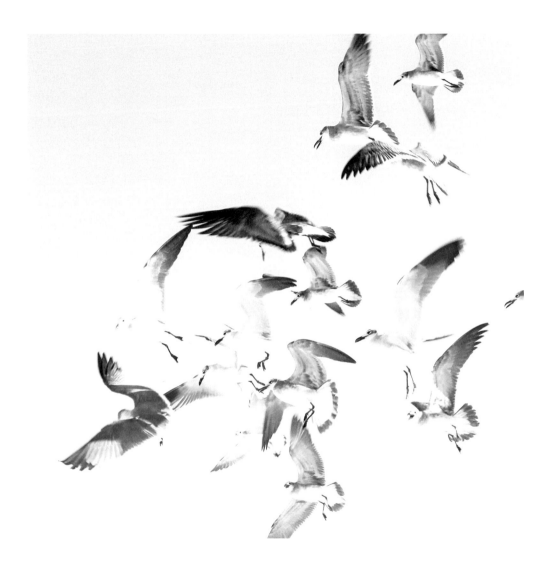

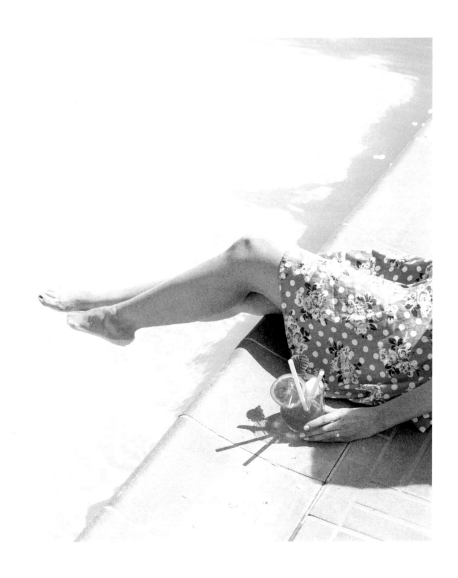

C22 M1 Y6 K0 C0 M30 Y14 K0

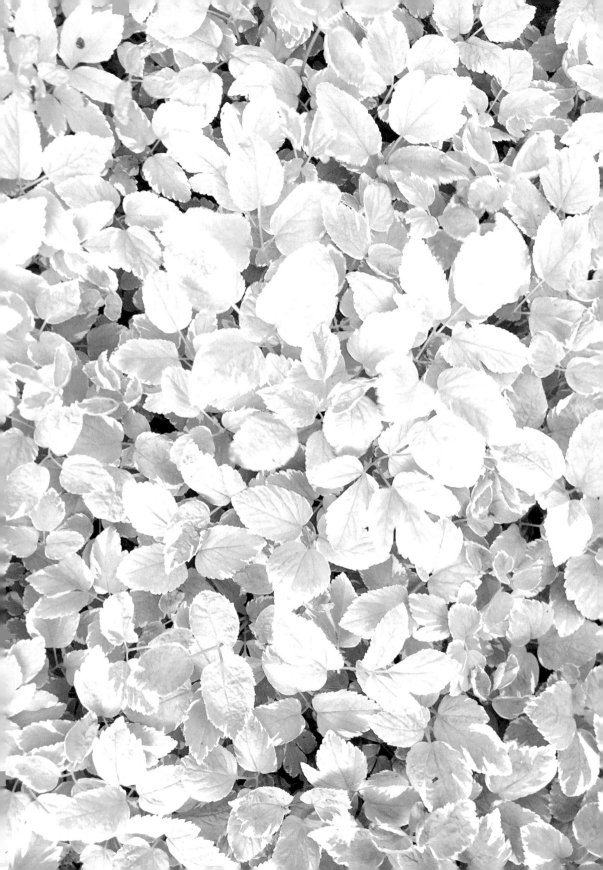

Life is a balancing act. We are forever caught between sprouting our roots deeper into the soil and reaching for the sun, the skies, infinity. We liken delicate stems blossoming, forever renewing and reinventing ourselves and our stance in this world. Dense forests, intricate leaves and wild flowers in a sea of lush, green grass lure us in with their ever-changing energies, their seasons a kaleidoscopic interpretation of the human experience. Palm leaves pierce our hectic surface, painting it evergreen.

Urban environments injected with patches and parks of green, majestic trees watching over thatched roofs and our intimate family settings ground us, soothe our everyday lives. We bring nature´s colours into our city lives, relying on them to drown out the clamour.

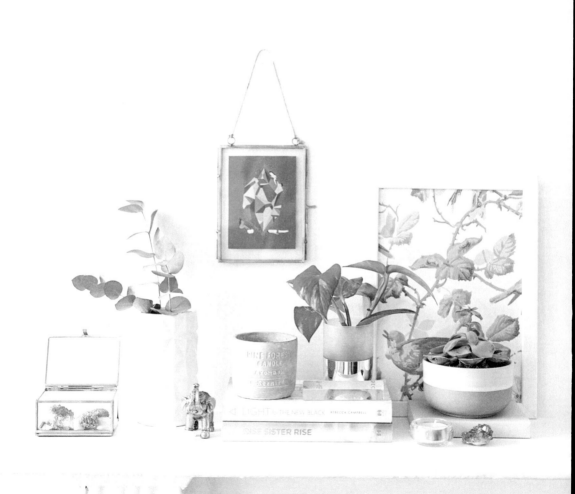

Green Consonance

C20 M4 Y20 K0 C7 M5 Y6 K0

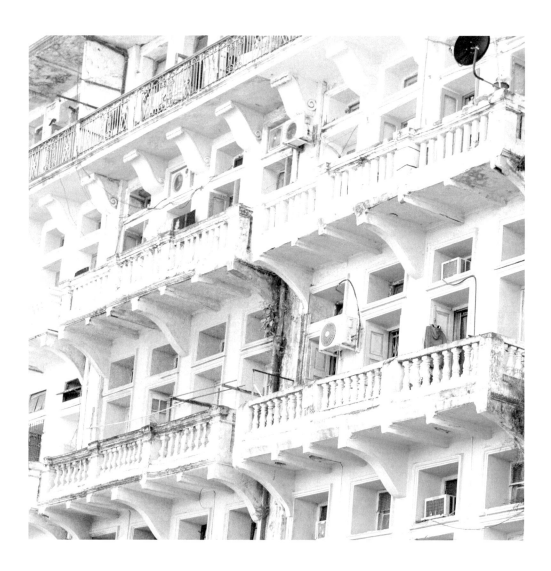

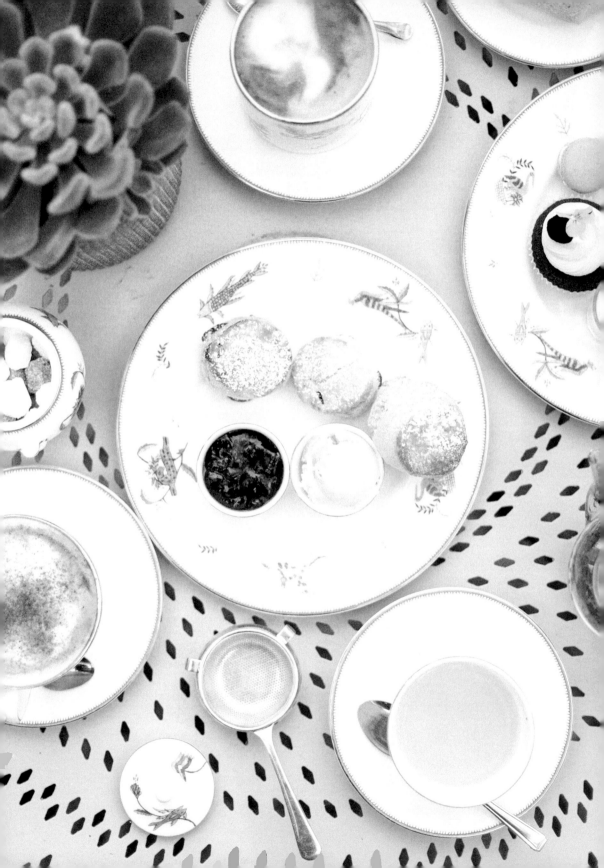

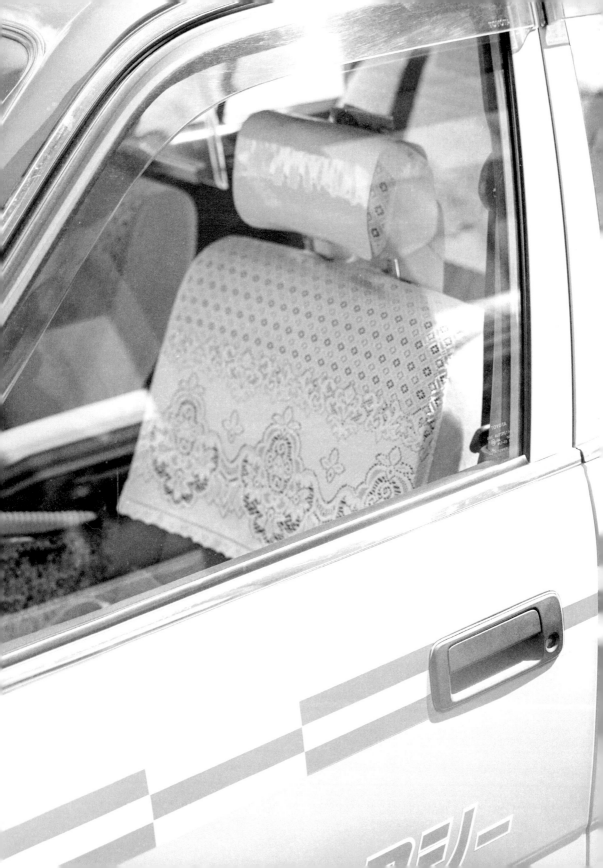

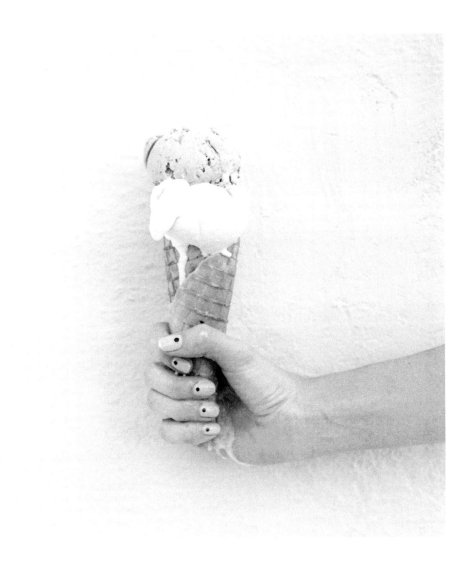

C22 M0 Y12 K0 C0 M24 Y3 K0 C0 M3 Y20 K0

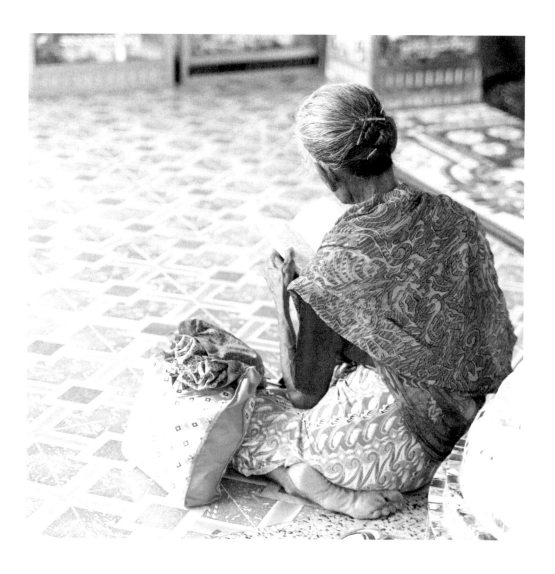

C15 M0 Y25 K0 C0 M15 Y33 K0

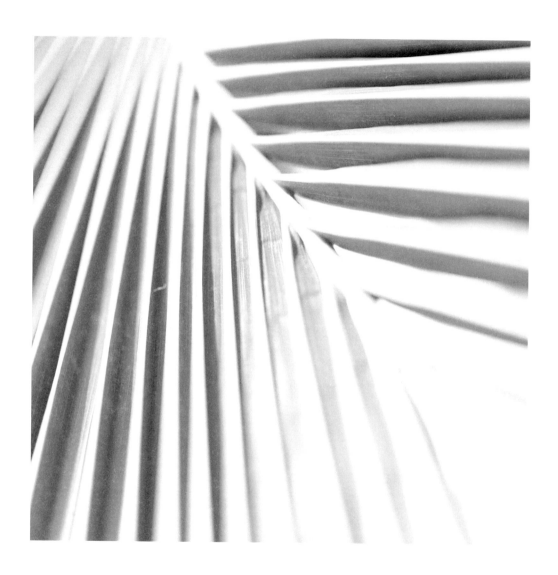

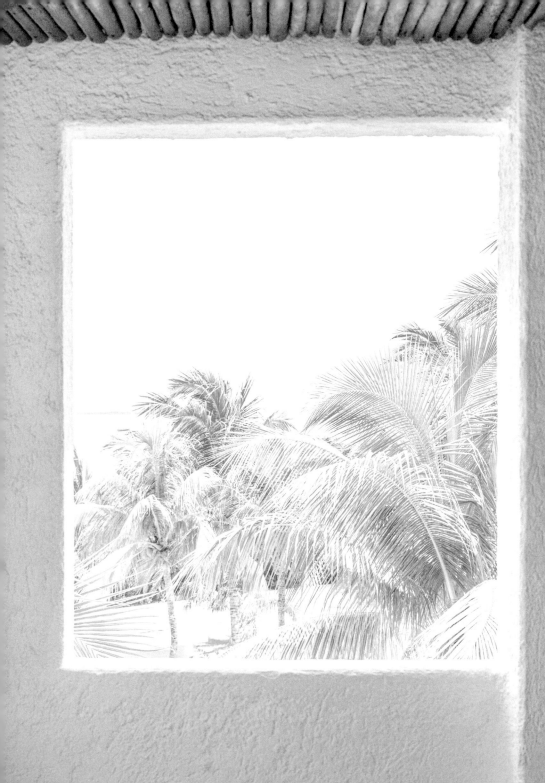

Like the sunrise and sunsets, pinks set the tone of our days. They light up our world without saturating our minds with profound thoughts and worries of hours passed, and dark nights to come. The colour, so feminine in nature, so calming in its presence, honours our vulnerability and encourages us to do the same. Like the red sea's gentle ripples, it carries us forth with great hope and optimism.

Amidst pink walls we come to rest. We shed the day's chaos of colours and breathe in a genuine feeling of safety and comfort. Feeling as though we are kissed by the soft touch of a rose petal, we are lulled into a meditative breathing rhythm and finally find back to ourselves.

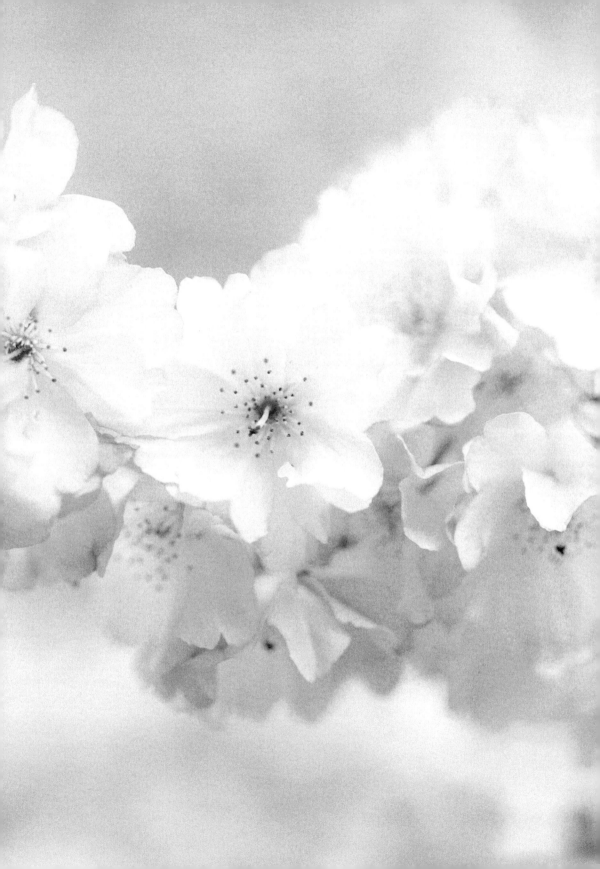

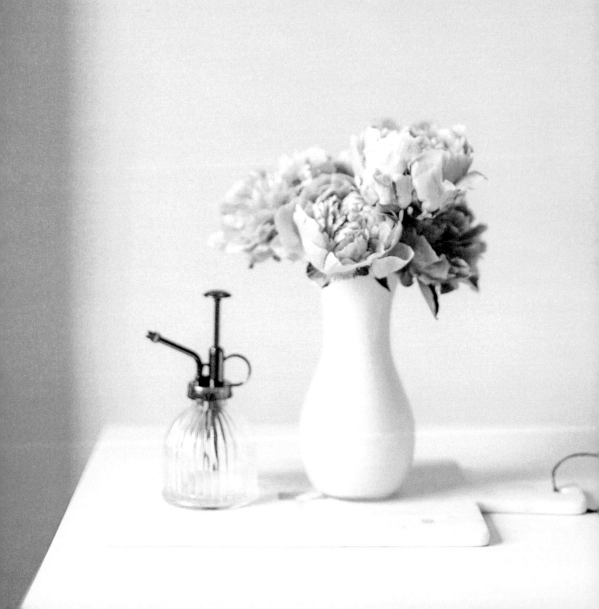

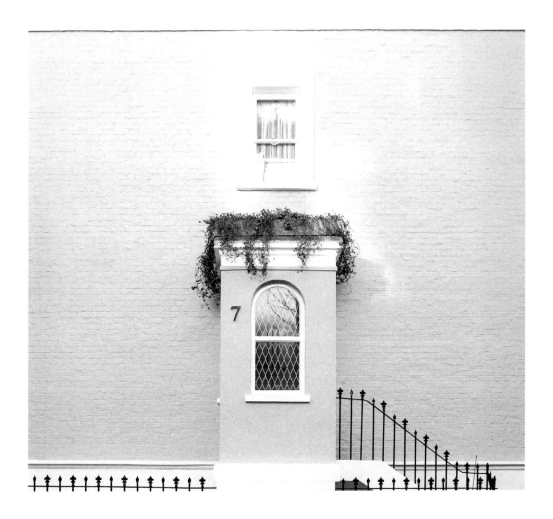

C14 M22 Y8 K0 C0 M13 Y11 K0 C6 M3 Y7 K0

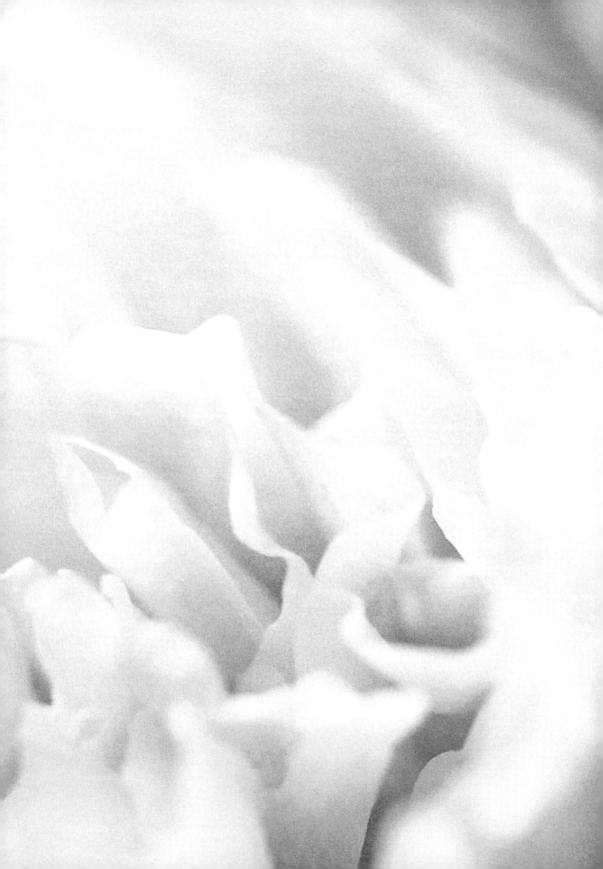

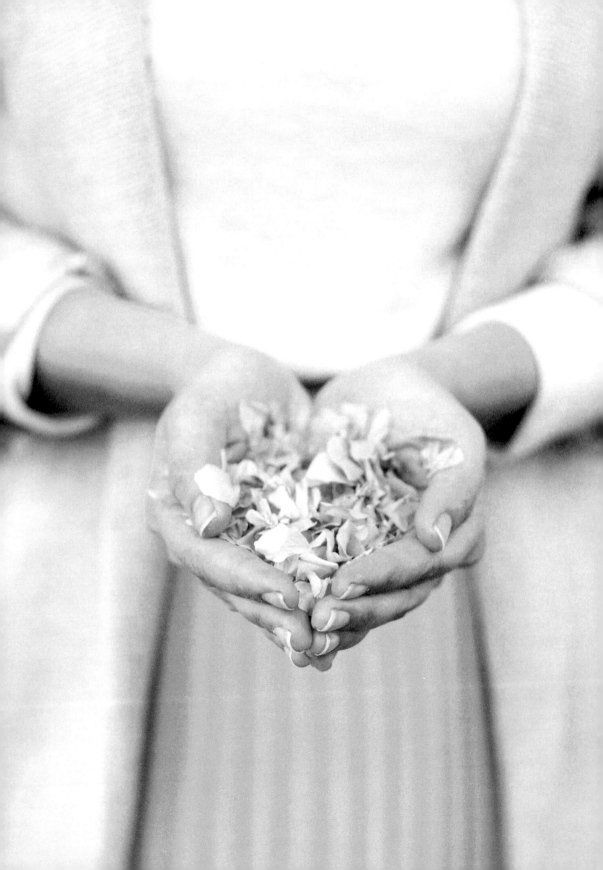

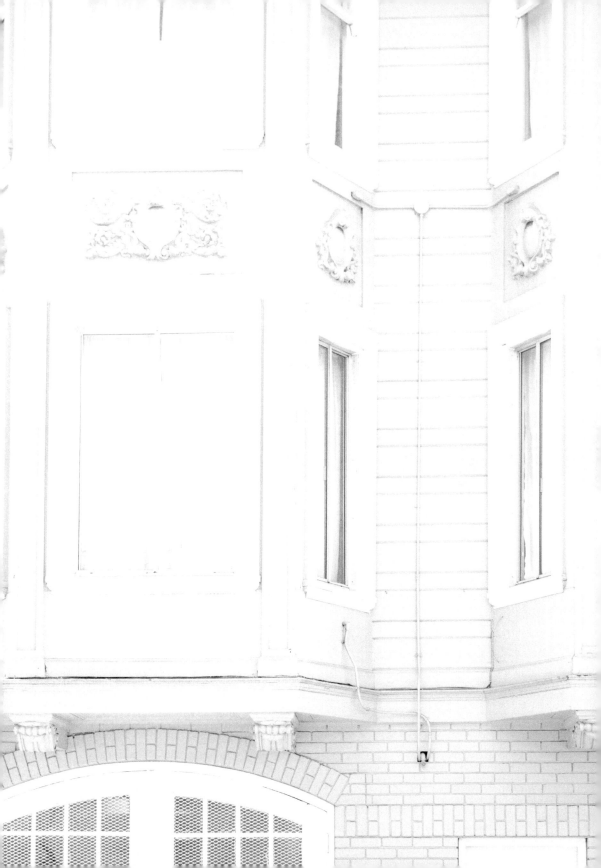

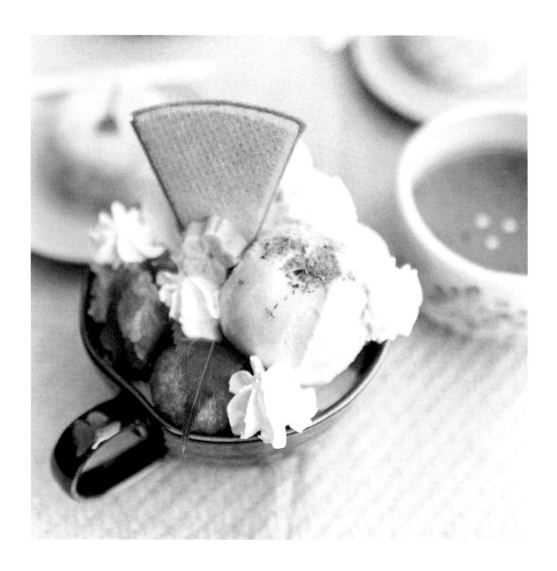

C0 M8 Y16 K0 C0 M18 Y0 K0 C18 M24 Y6 K0

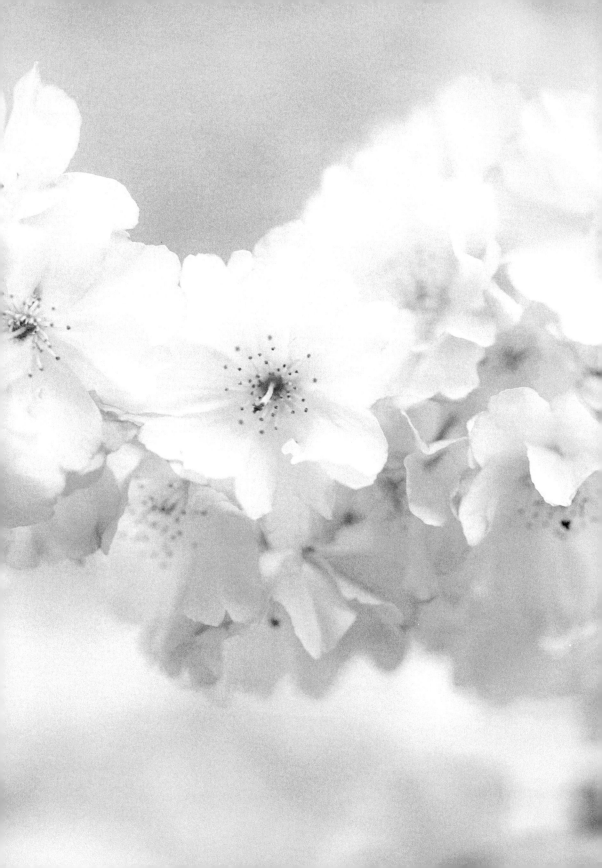

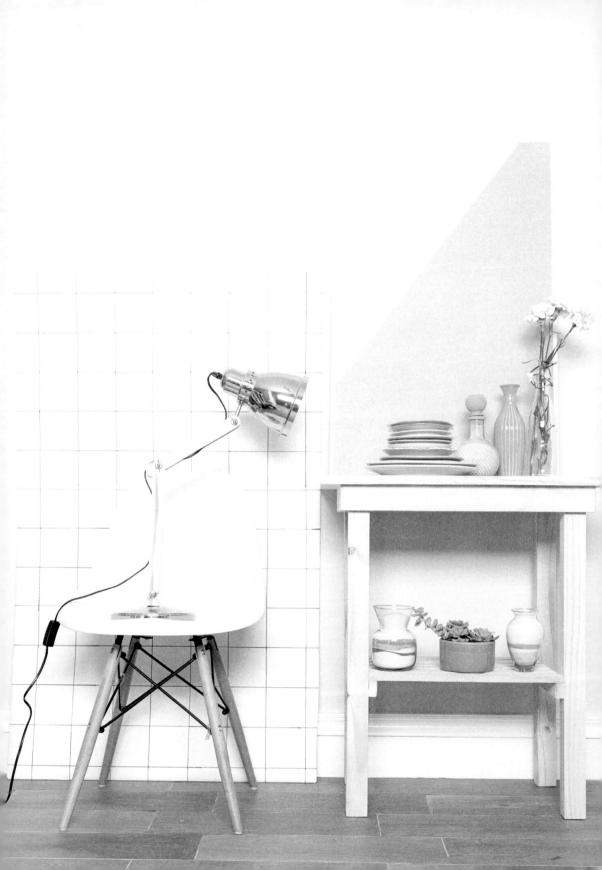

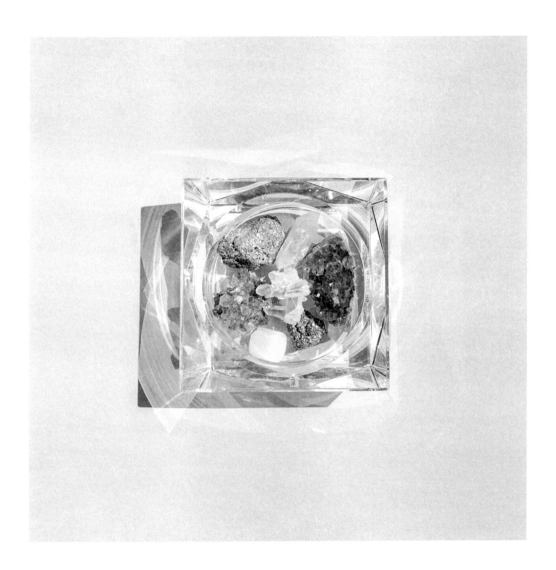

C0 M0 Y22 K0 C0 M17 Y12 K0

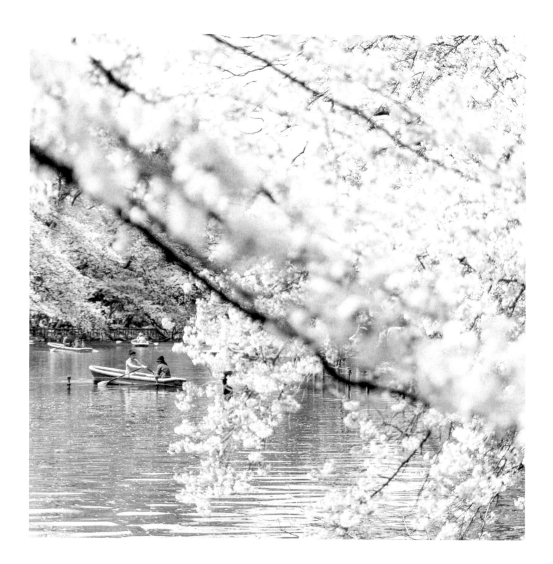

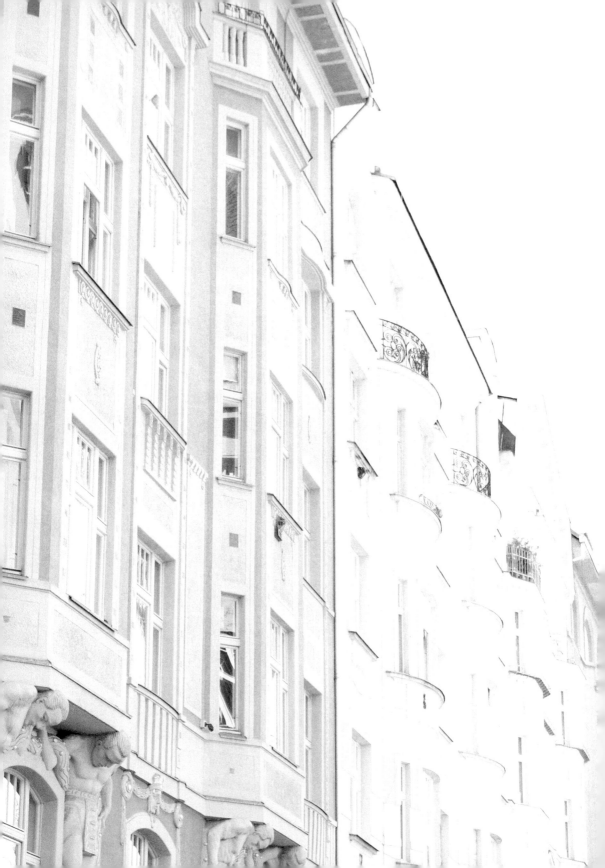

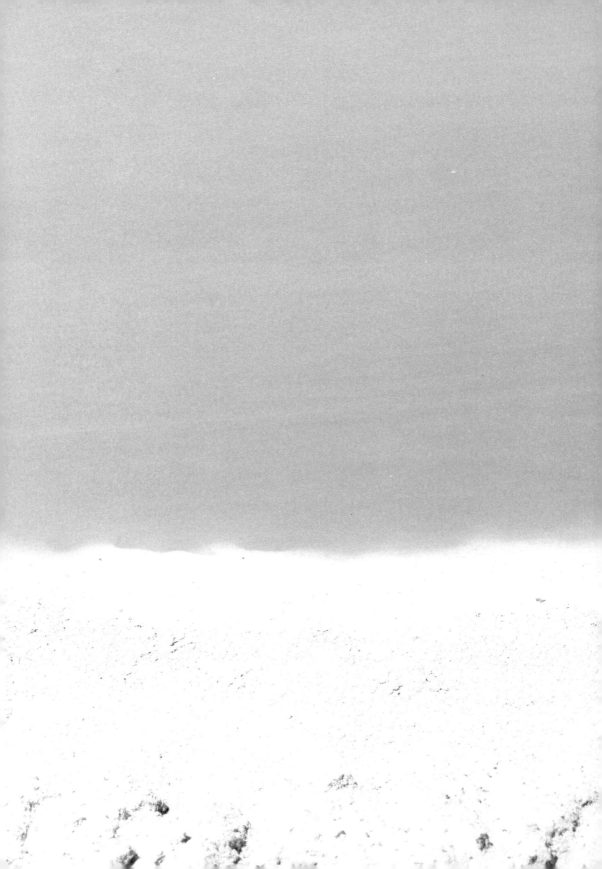

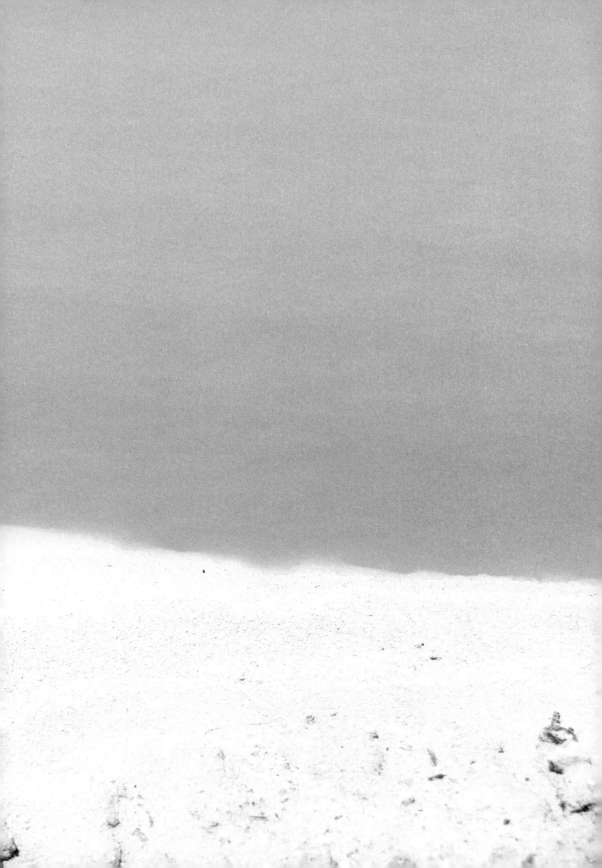

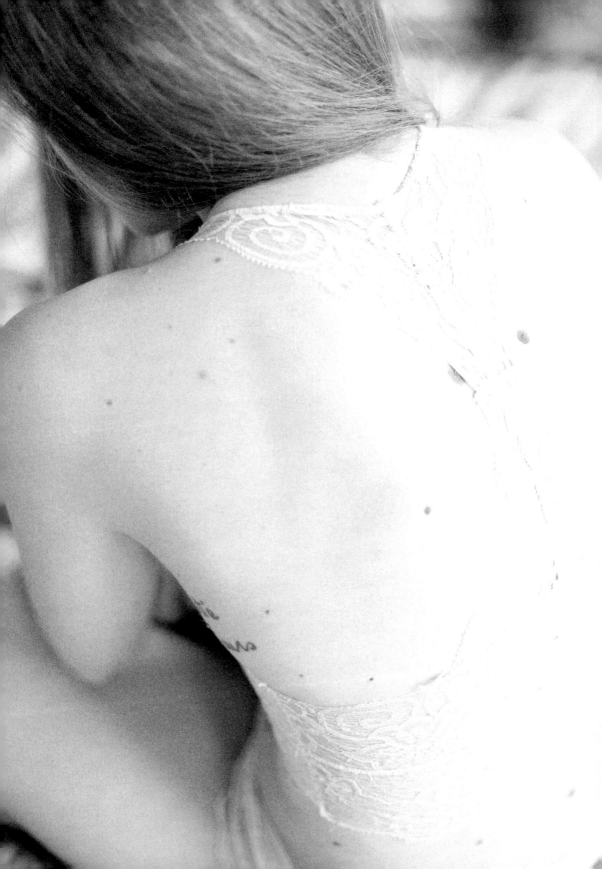

We loudly announce our entrance with bright colours and patterns, and relish in an environment longing to know the essence of our being. It takes confidence, charisma and charm – attributes we do not always have the strength to summon. Some days invite us to hide beneath the neutral greys of our bedsheets, to absorb our myriad of emotions until we can succumb to the stillness.

We blend into grey backdrops as we mature in age and wisdom, having come to understand that busy colours aren't always heard. Instead, we find solace in the unemotive, sparking people's curiosity through modesty rather than grandeur.

C6 M5 Y3 K5

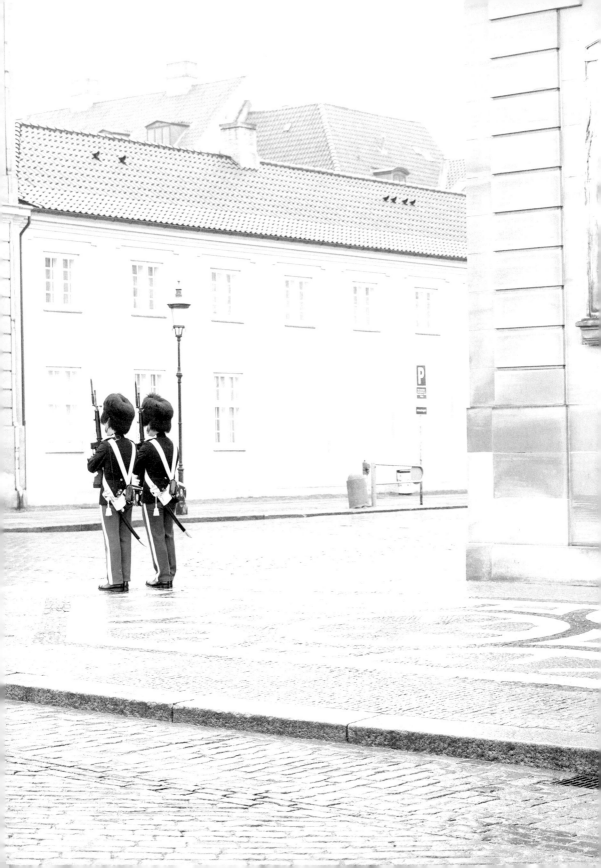

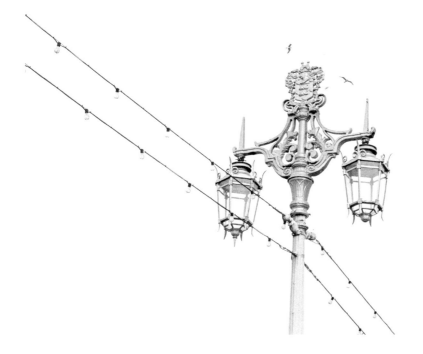

C15 M12 Y20 K0 C8 M5 Y7 K0

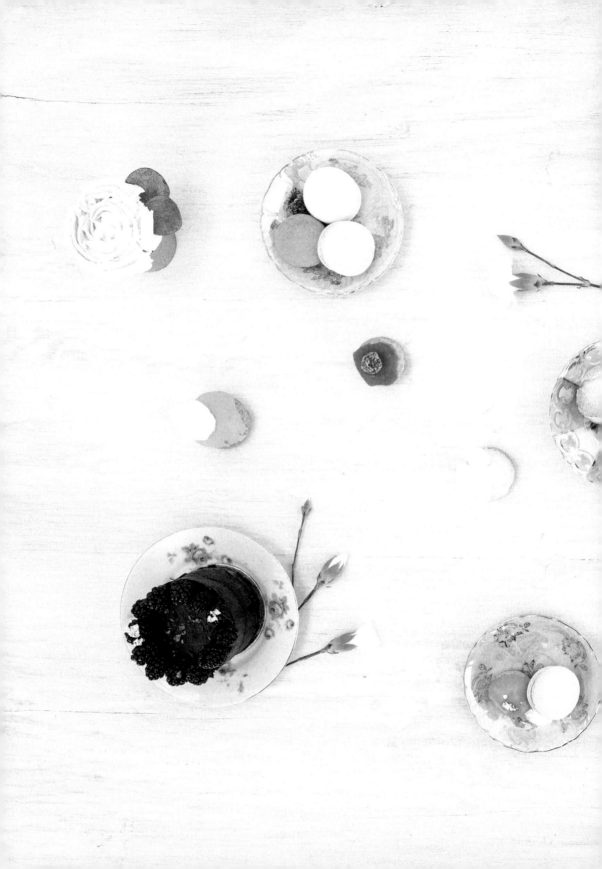

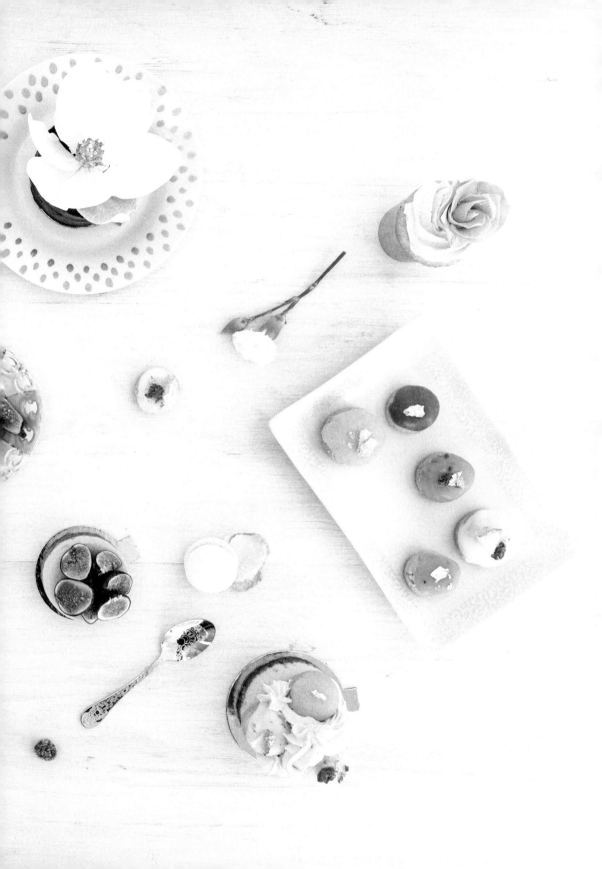

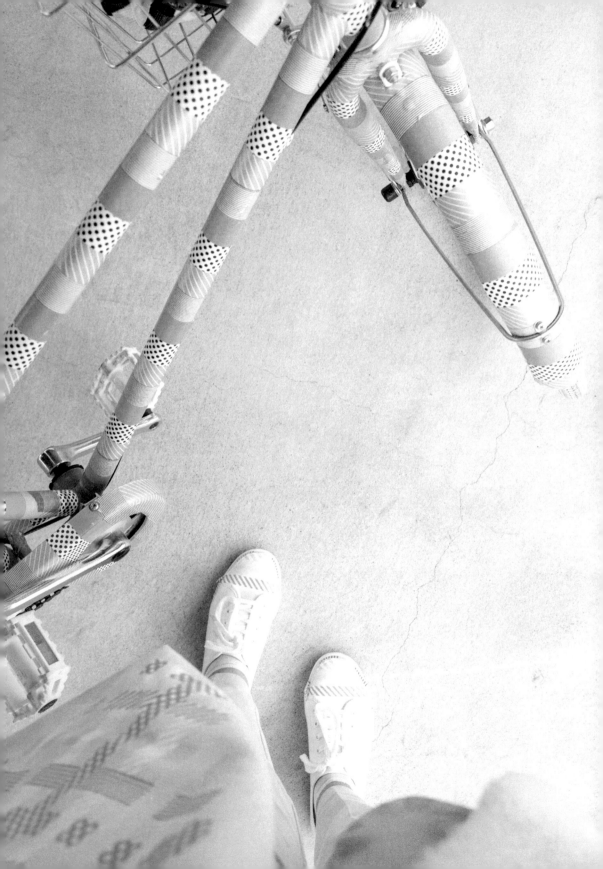

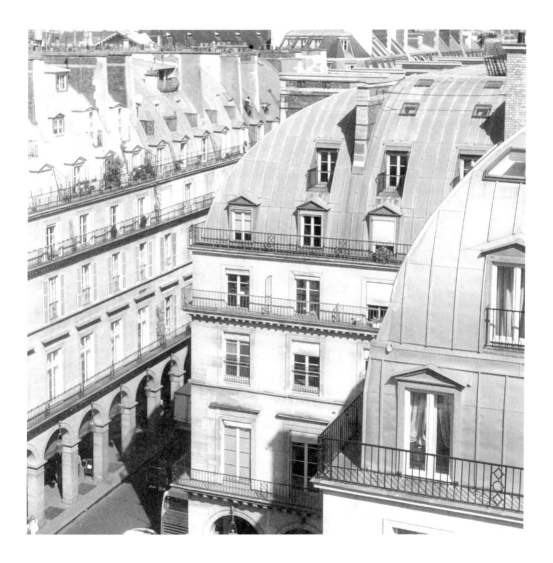

C6 M6 Y8 K0 C15 M8 Y8 K0

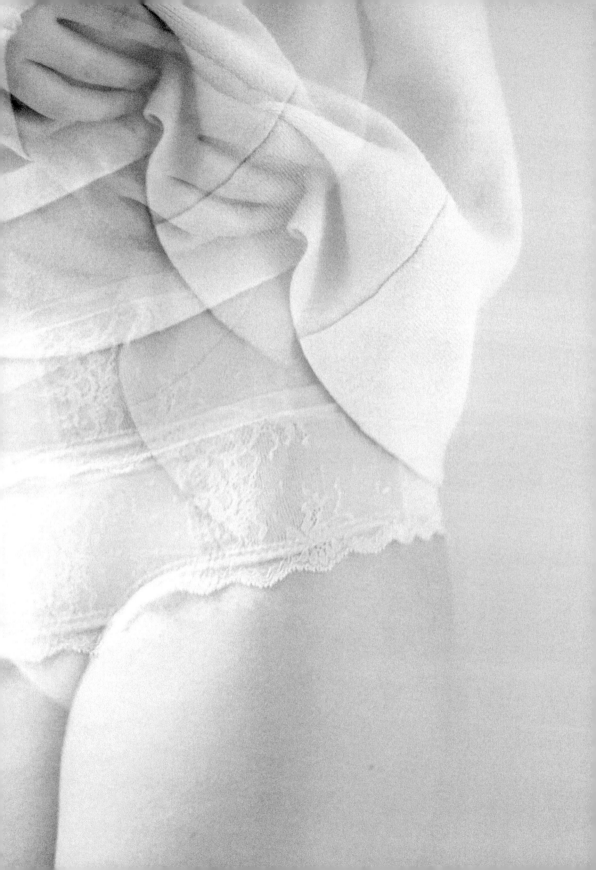

We refer to sunny dispositions – a smile or personality with the power to light up an entire room. The colour yellow itself, is a sunny disposition. We associate it with the warming rays of the sun, the silky petals of yellow roses, the quirky grimace of a citrussy fruit. It lights us up, inside and out, with cheerful optimism and creativity.

Yellow spurs our analytical minds when used in drab environments and un-familiar settings. With confidence, we aim to read between the lines and gain new perspectives as we navigate through its different shades and sentiments, until they become a reflection of our own, independent spirit.

C1 M3 Y23 K0

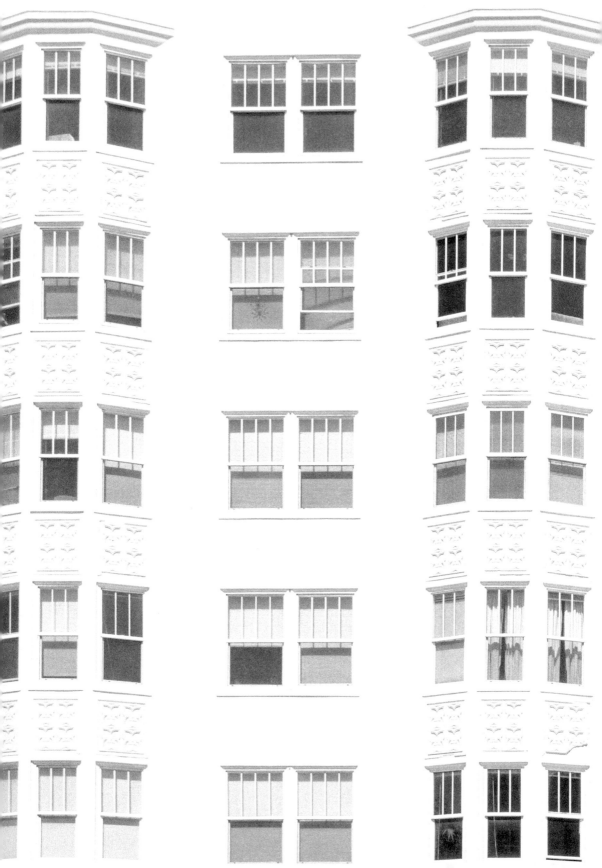

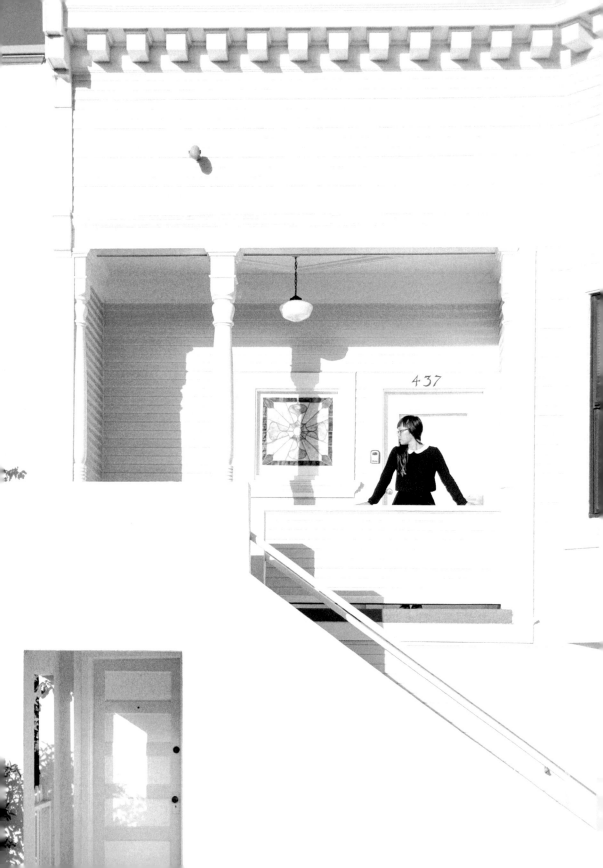

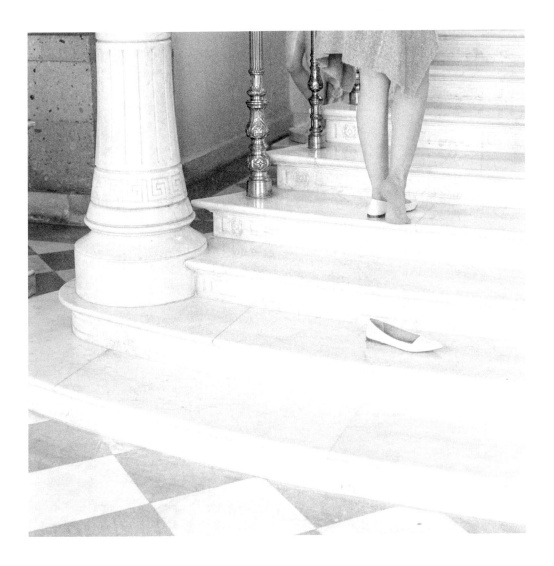

C2 M5 Y22 K0 C12 M6 Y6 K0

Optimistic Yellows

C2 M8 Y40 K0 C17 M6 Y0 K0

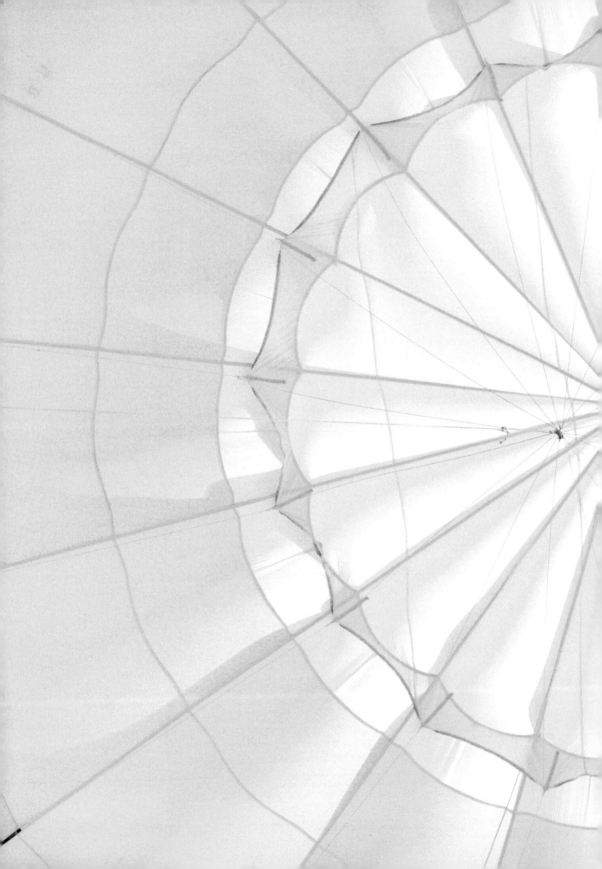

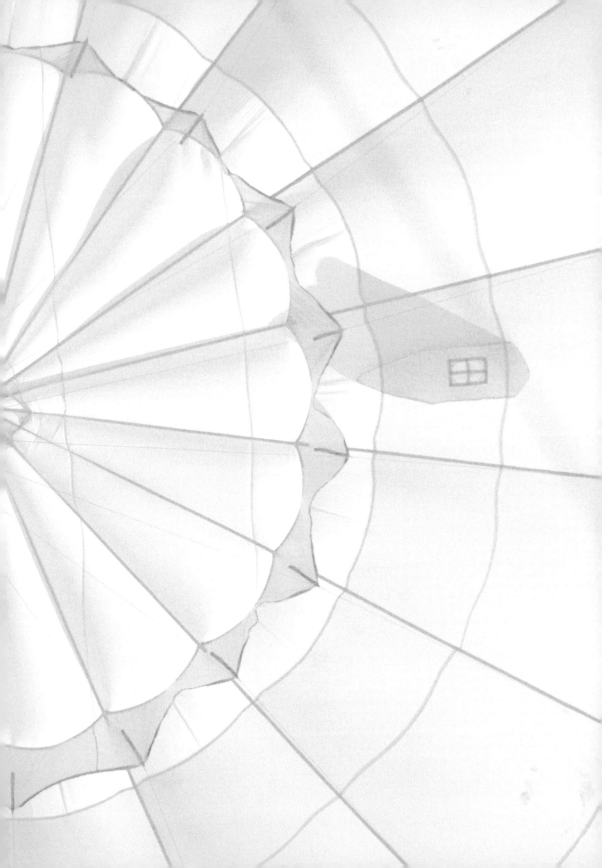

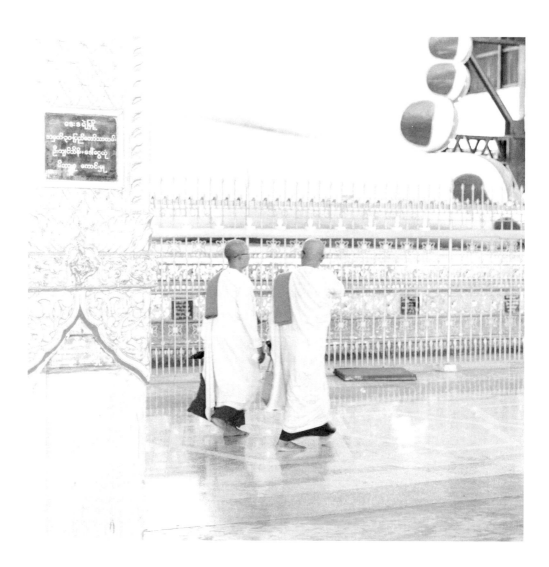

C7 M14 Y7 K0 C5 M5 Y30 K0

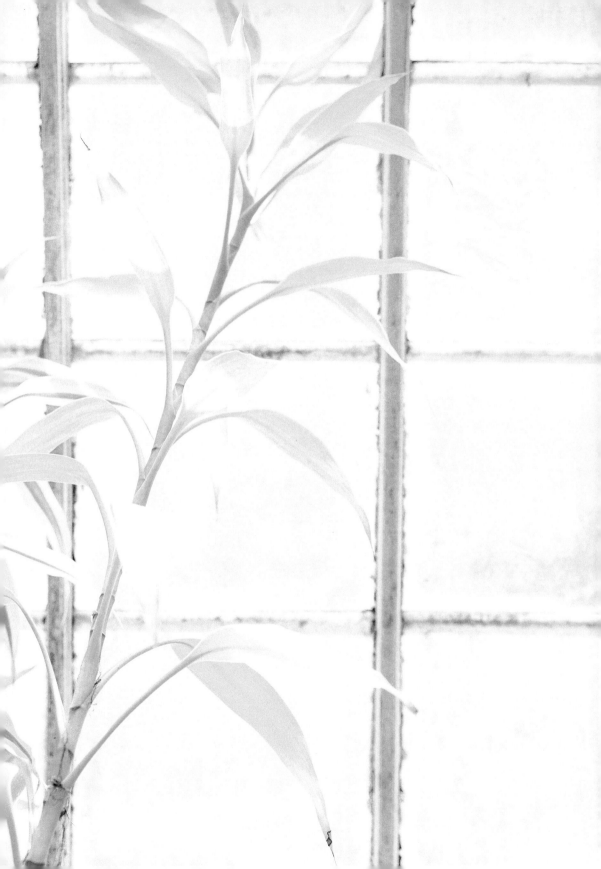

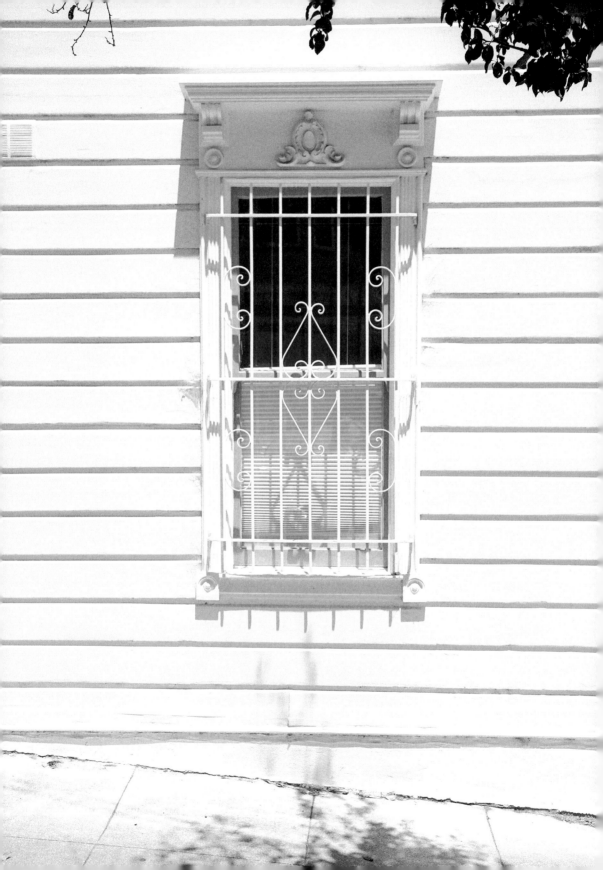

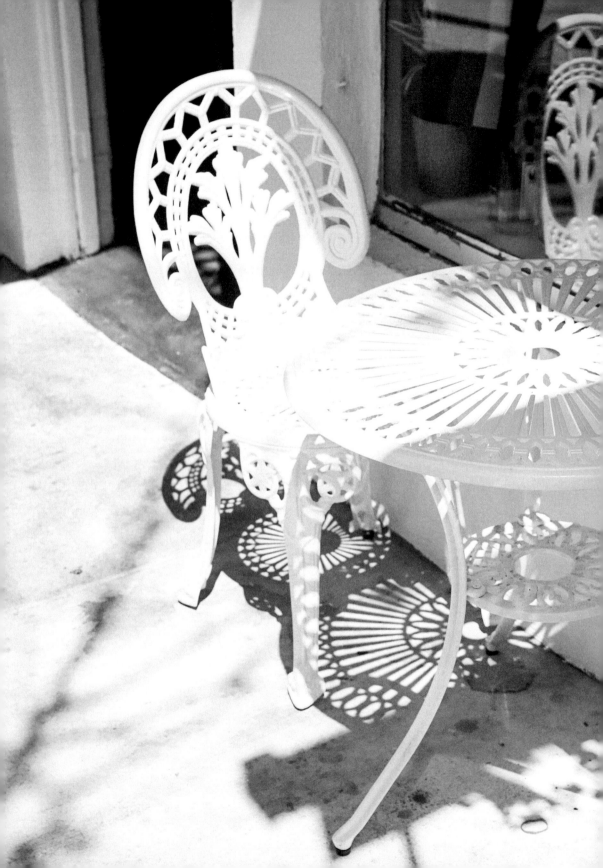

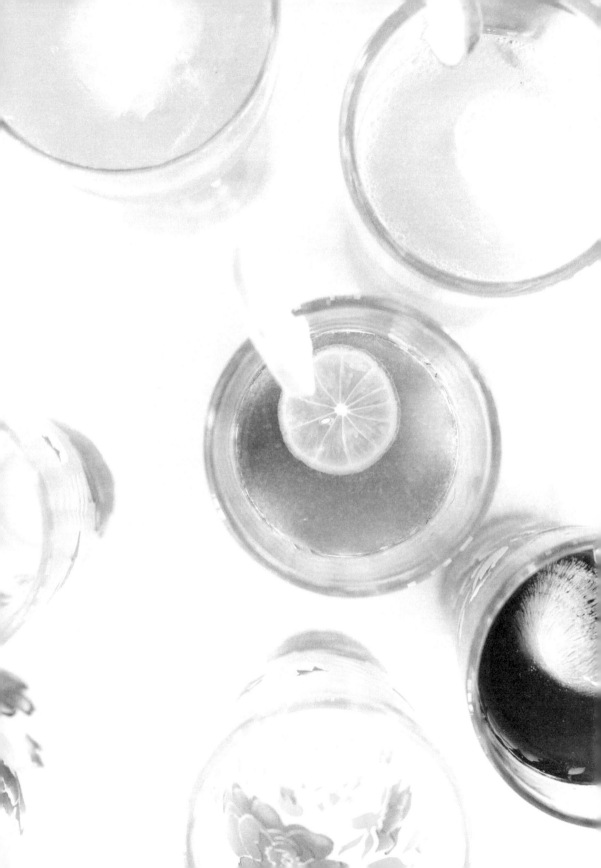

Orange leather-bound diaries eternalize scribblings of our mad adventures in this life, in this world. We suck revitalizing energies out of tangerine-flavoured popsicles and share it with the people around us as we become tangled in social vines blossoming pumpkin-orange. We thrive in our independence, we conquer when sipping 100 Proof Martinis with one-hundred loyal friends, and bask in persimmon comfort.

As autumn leaves burnt crimson and vermillion by Indian summers begin to fall and gather in crackling piles, we too gain the courage to evolve with a new season. We call for our creative forces and allow them to send warmth into crisp country nights.

C0 M11 Y17 K0

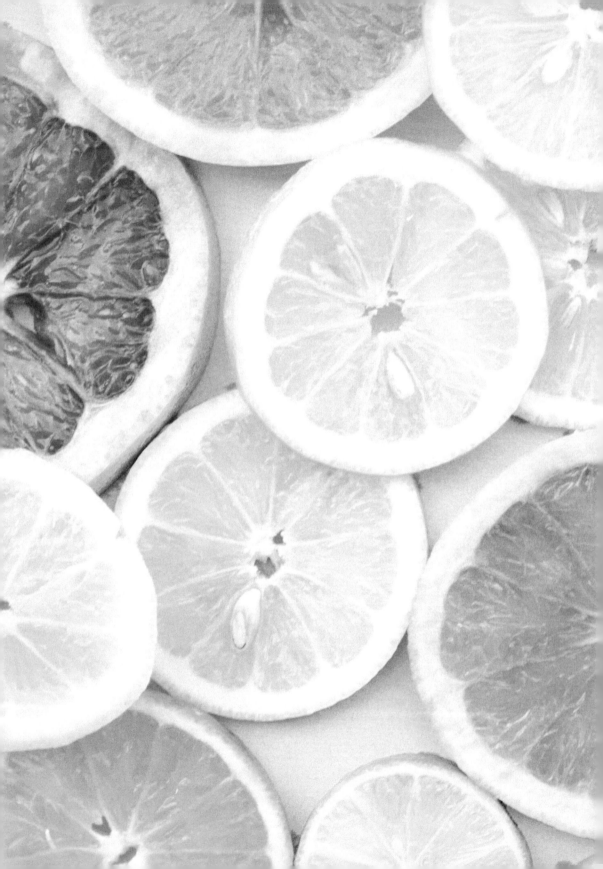

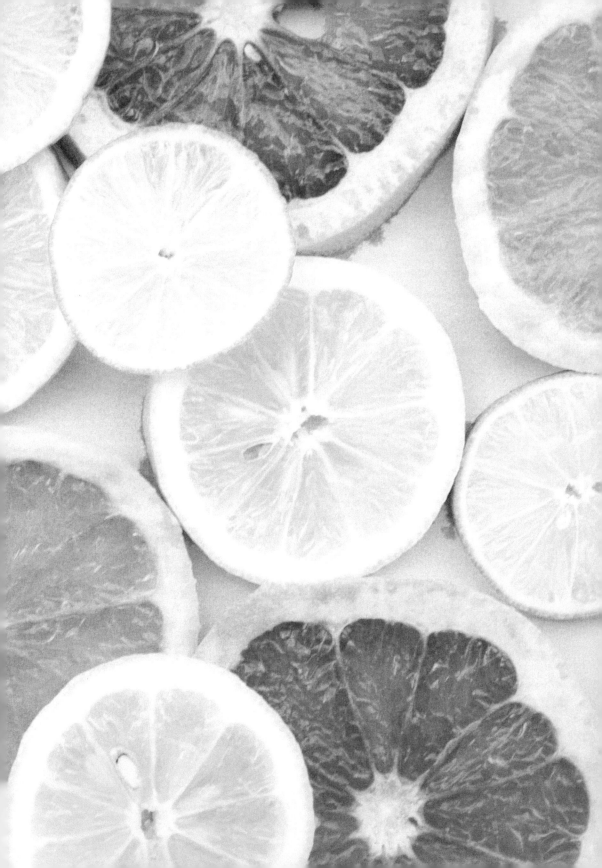

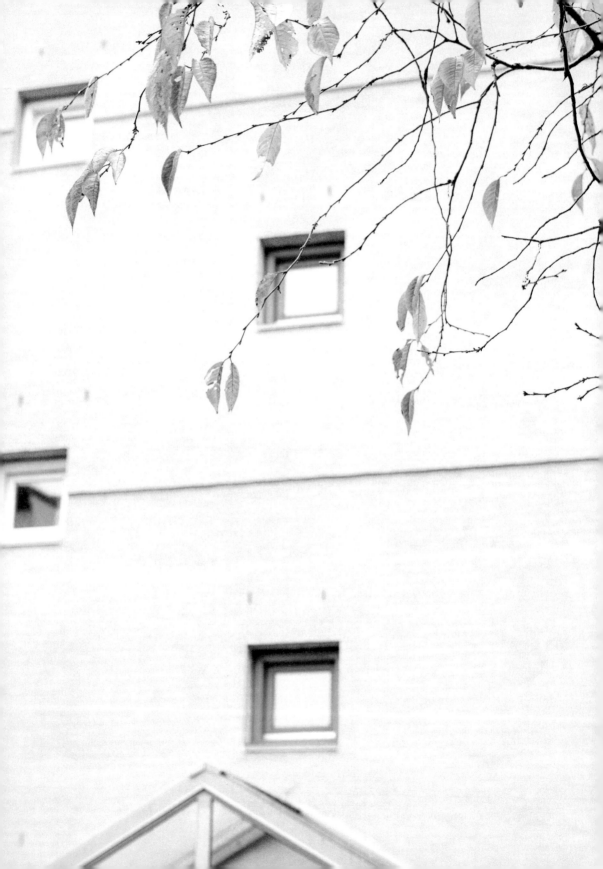

Adventurous Orange

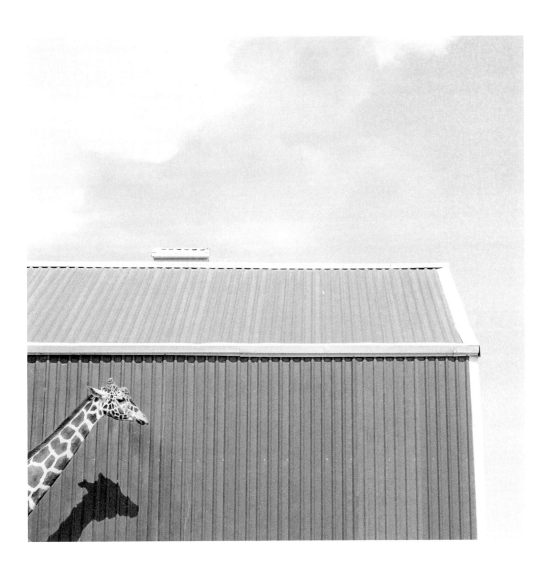

C0 M10 Y20 K0 C0 M24 Y24 K0

C3 M6 Y25 K0 C0 M18 Y30 K0 C14 M0 Y19 K0

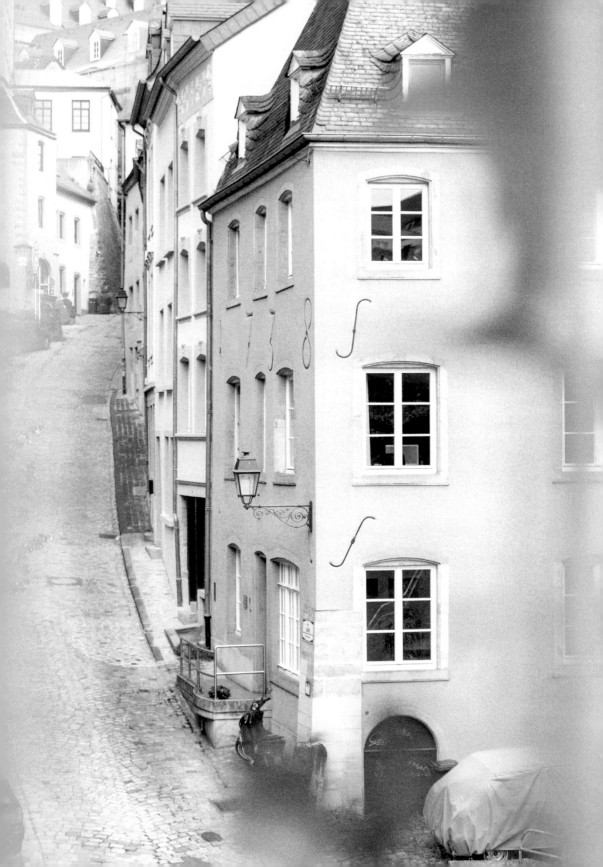

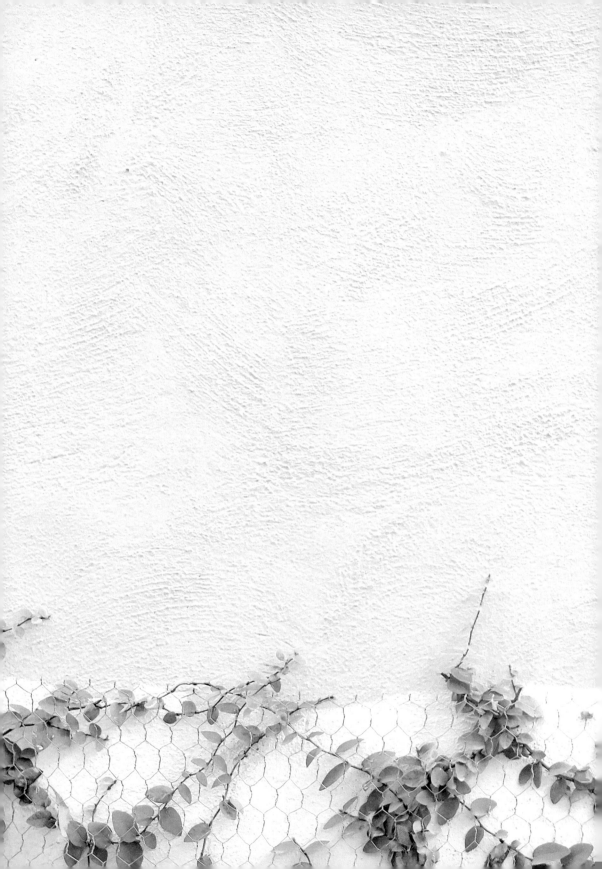

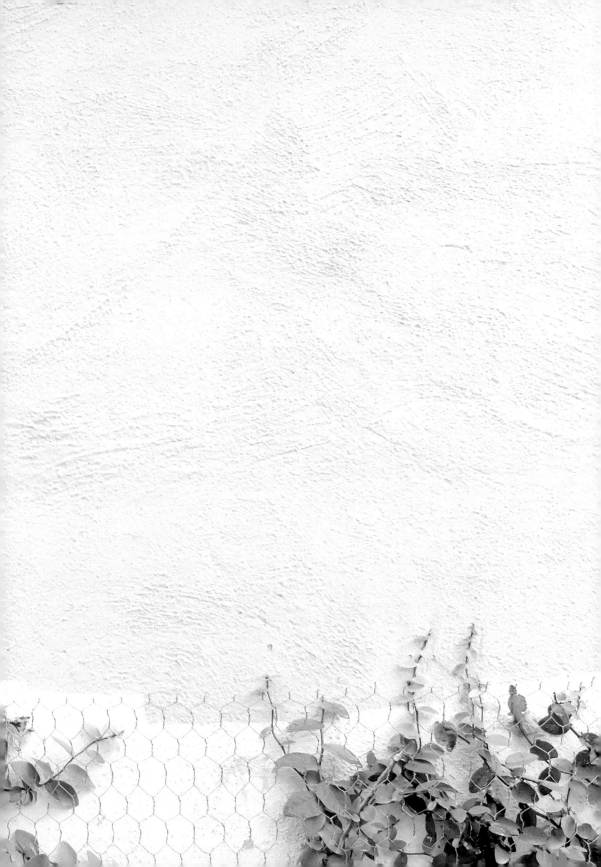

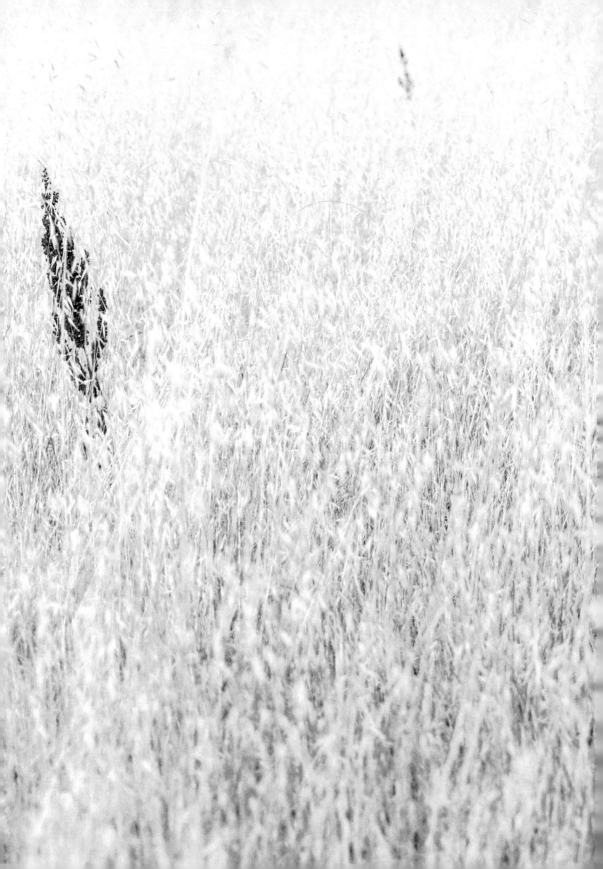

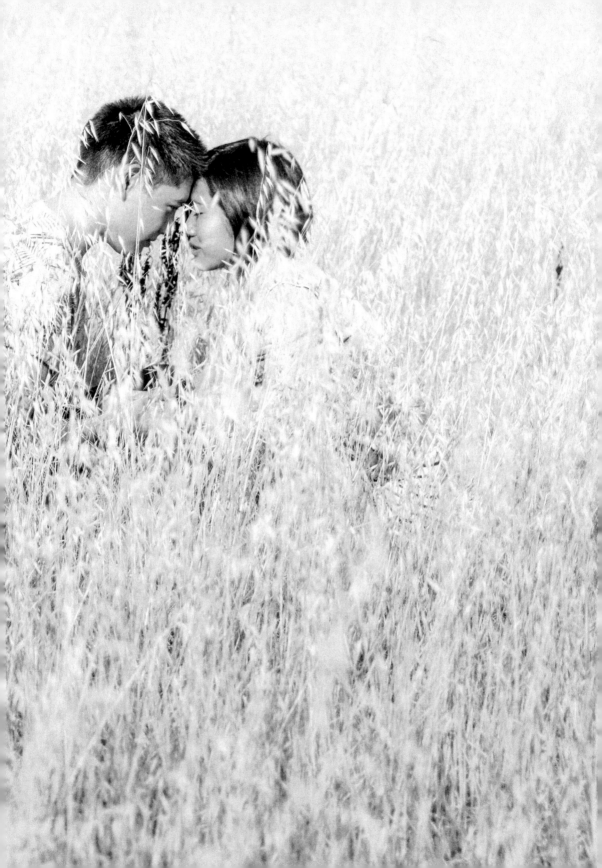

Adventurous Orange

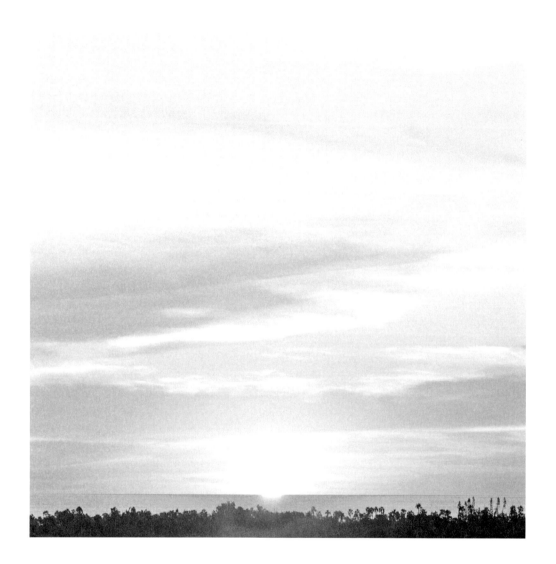

C0 M8 Y28 K0 C9 M14 Y7 K0

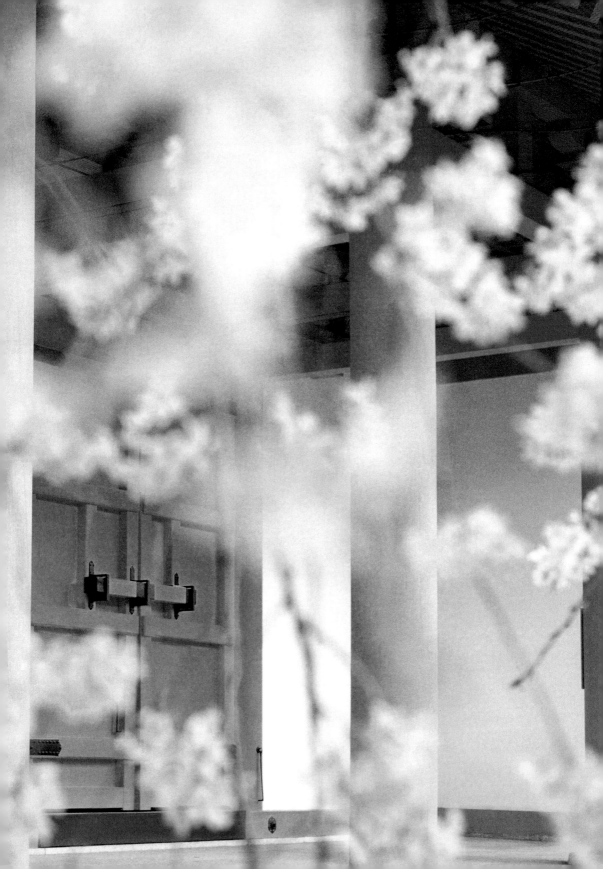

Majestic and wise, purple enshrouds everything in magical mystery so pure, it reaches down to our very core, forever reminding us of our inner truth. Our indigo eye tunes up with our intuition, reaping the spiritual knowledge needed to break through the concrete of our urban jungles and blossom in gentle violet tones.

Inconspicuously present, we absorb mauve sagacity as we rest our head on patterned surfaces and descend the thistle-striped staircase to come face to face with the images and sentiments of our deepest subconscious. The dreams that fuel our waking lives and rule the colour palette with which we paint our world.

C6 M11 Y0 K0

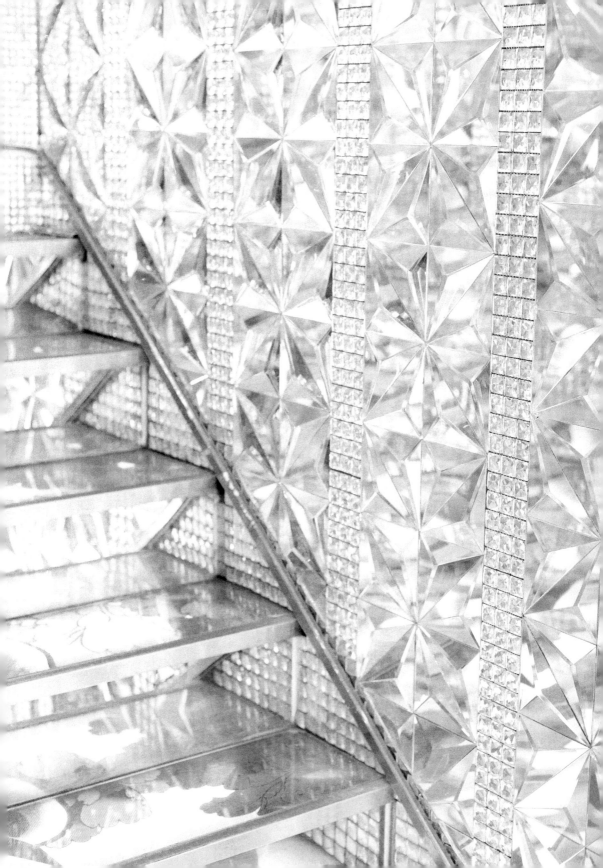

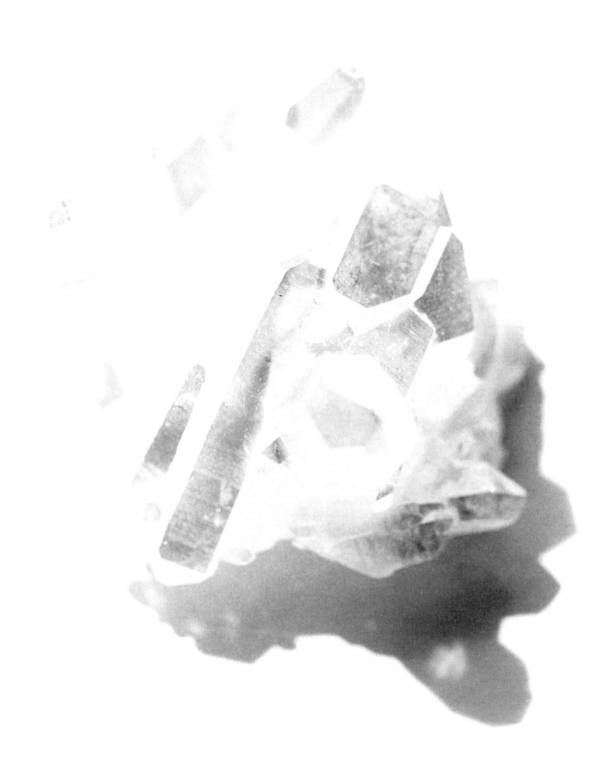

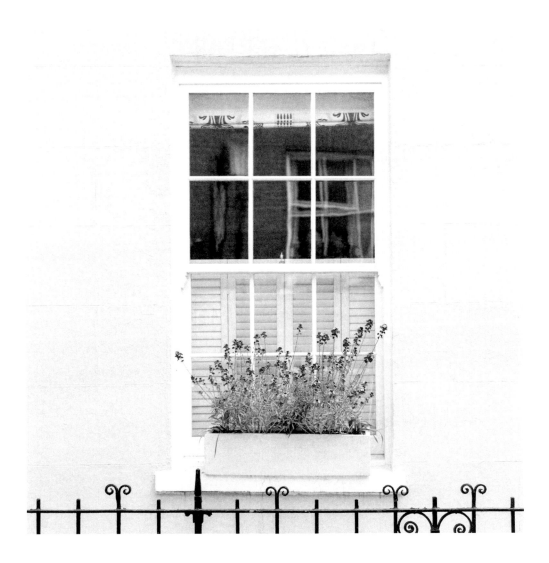

C0 M0 Y32 K0 C7 M29 Y0 K0 C8 M5 Y3 K0

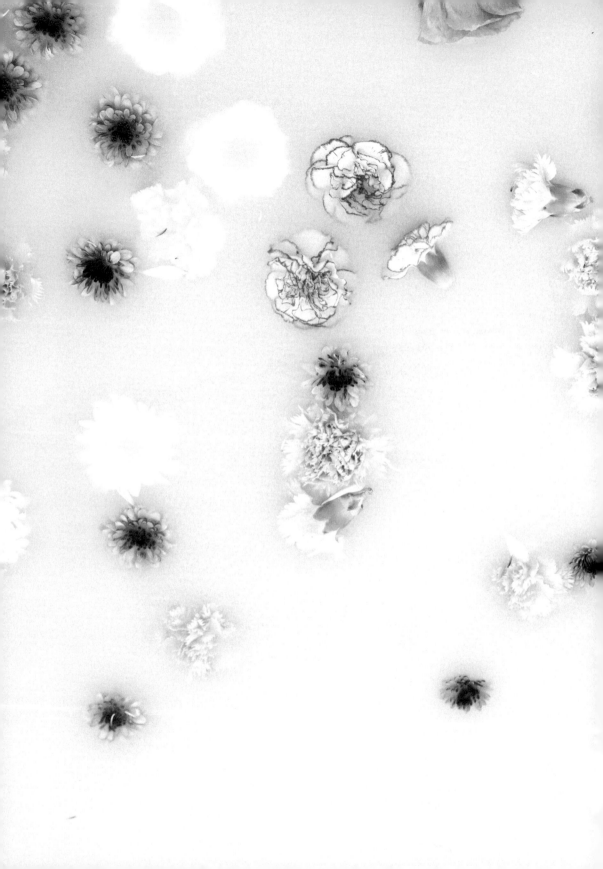

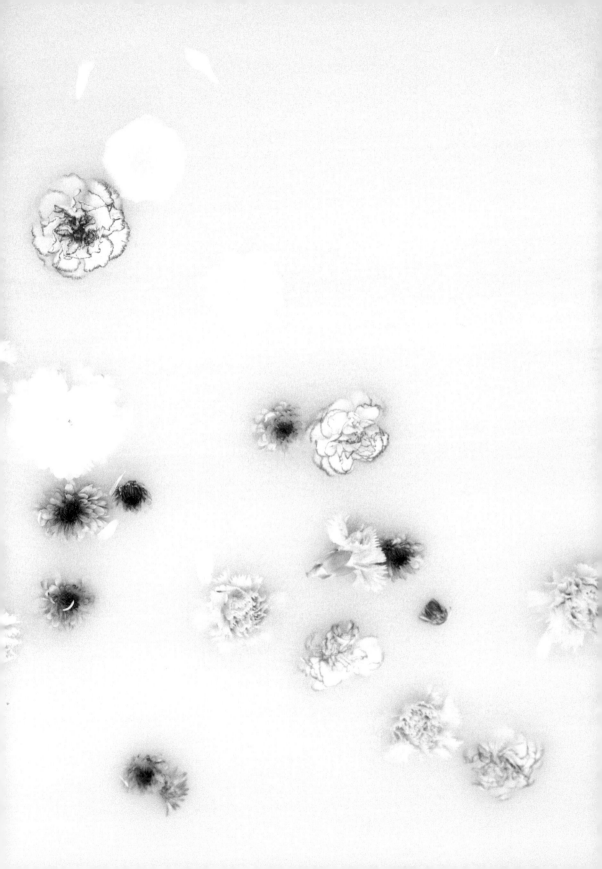

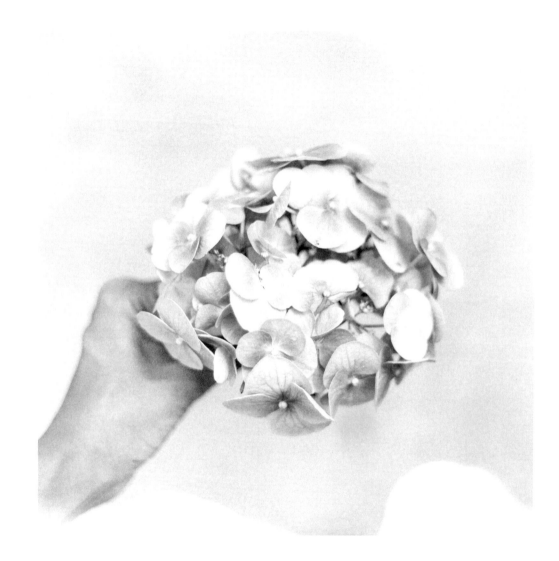

Purple Magic

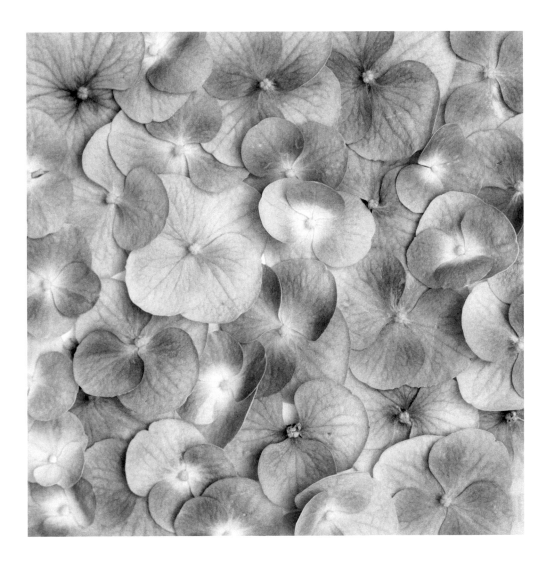

C15 M16 Y0 K0 C21 M10 Y4 K0 C16 M5 Y16 K0

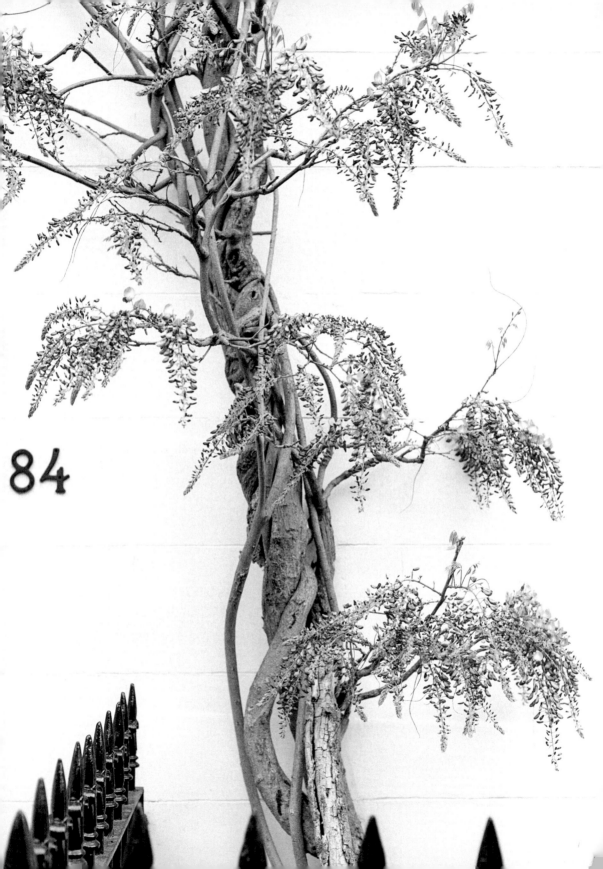

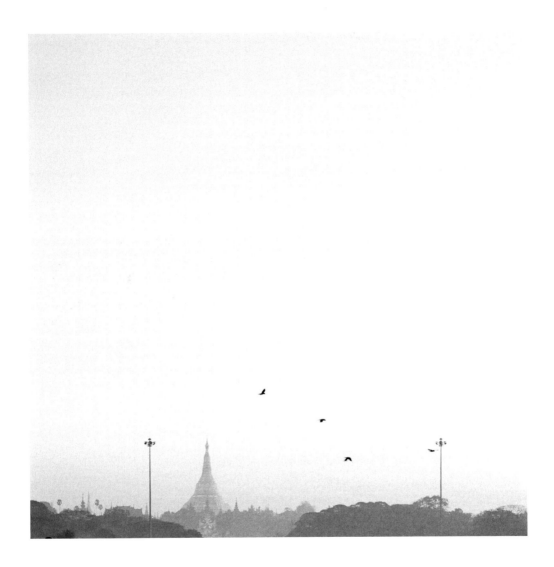

C0 M9 K15 K0 C12 M12 K2 K0

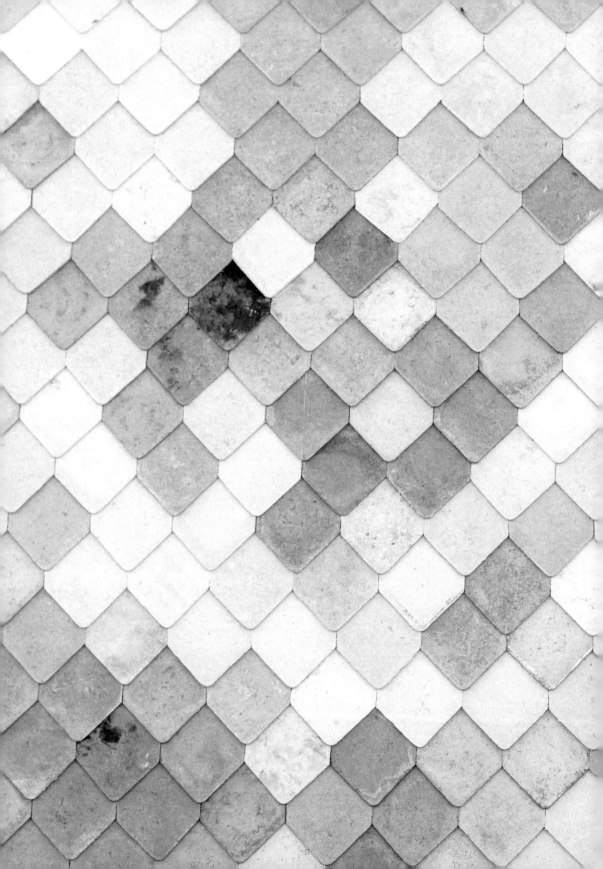

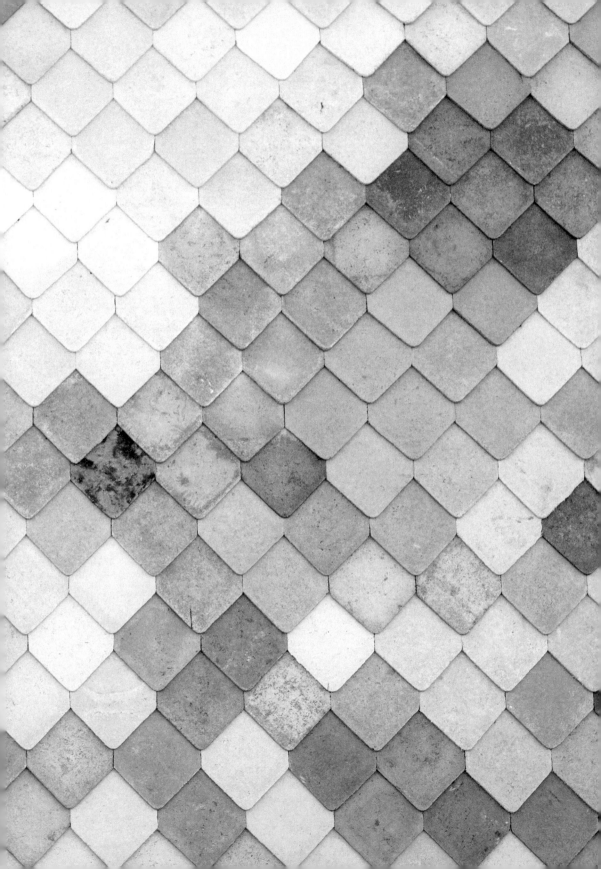

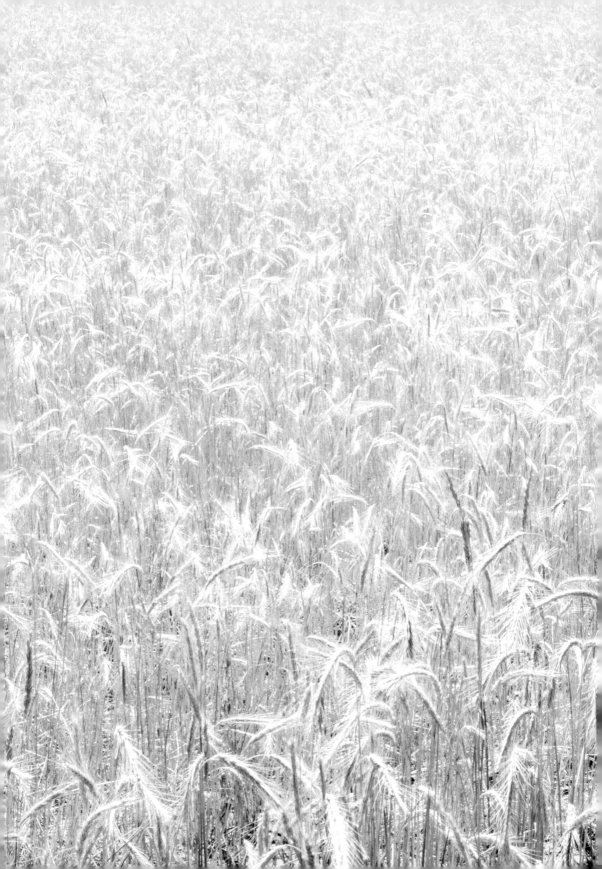

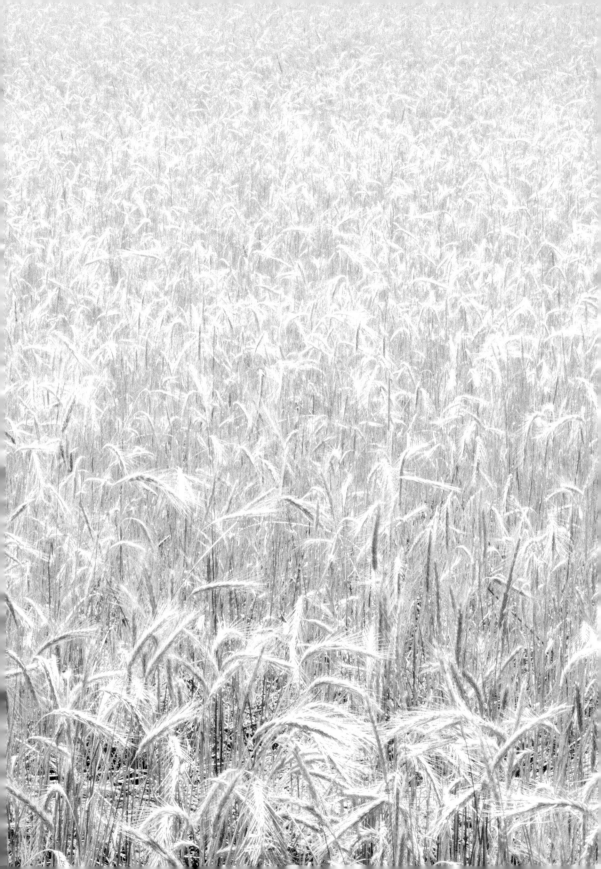

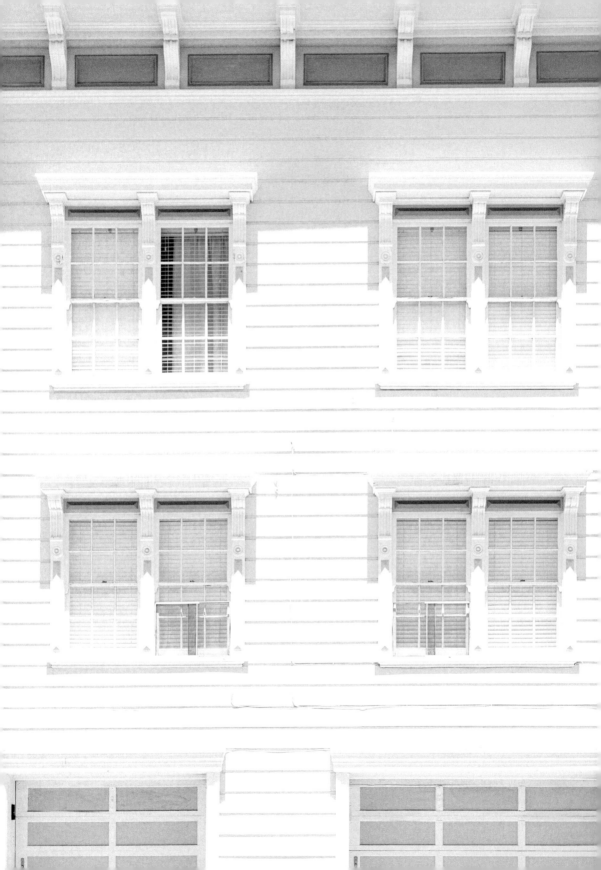

We come into this world as blank, white canvasses ready to be painted, tainted with our own chosen colours. Pure and innocent, we act solely on instinct until each life-event stains our pristine surface with spatters as colourful and versatile as those that build the arc of a rainbow.

And when we can no longer see through a haze of colours, we turn to white. We hide beneath white blossoming branches, wrap ourselves in ivory garments, and find serenity in honeydew walls. We reset and neutralize. Our canvasses washed clean once more, we exfoliate old, crusting colours and return to simplicity.

C4 M4 Y4 K0

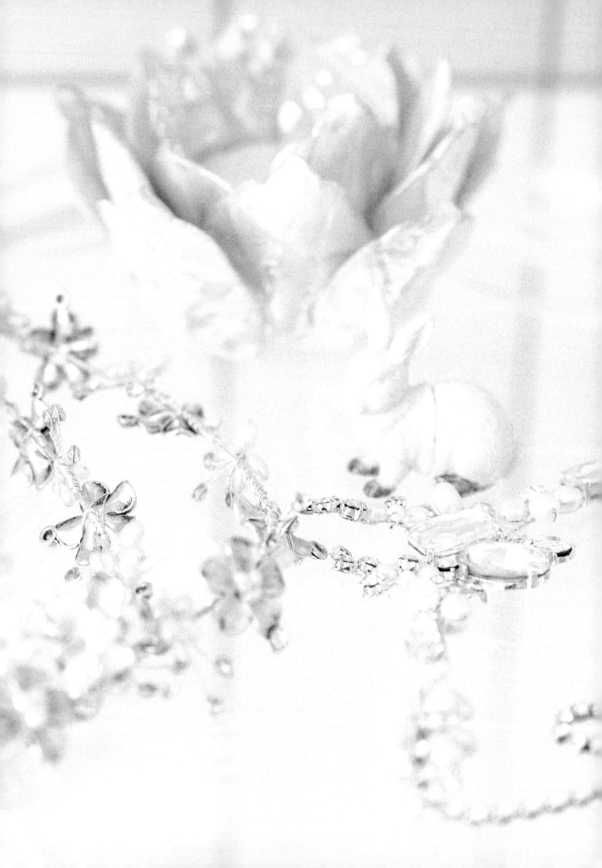

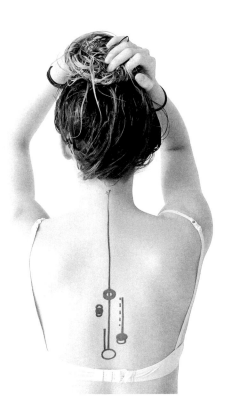

C7 M7 Y8 K0 C3 M9 Y12 K0

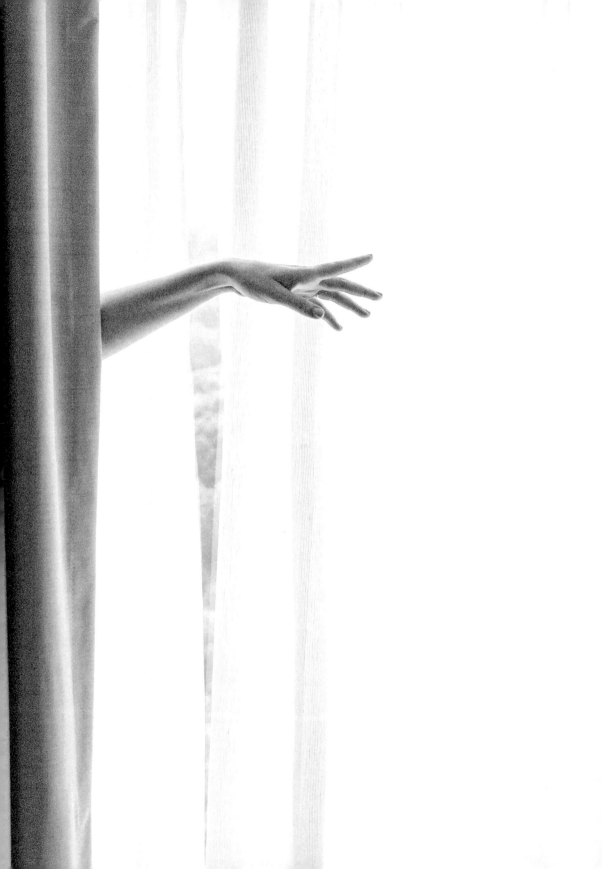

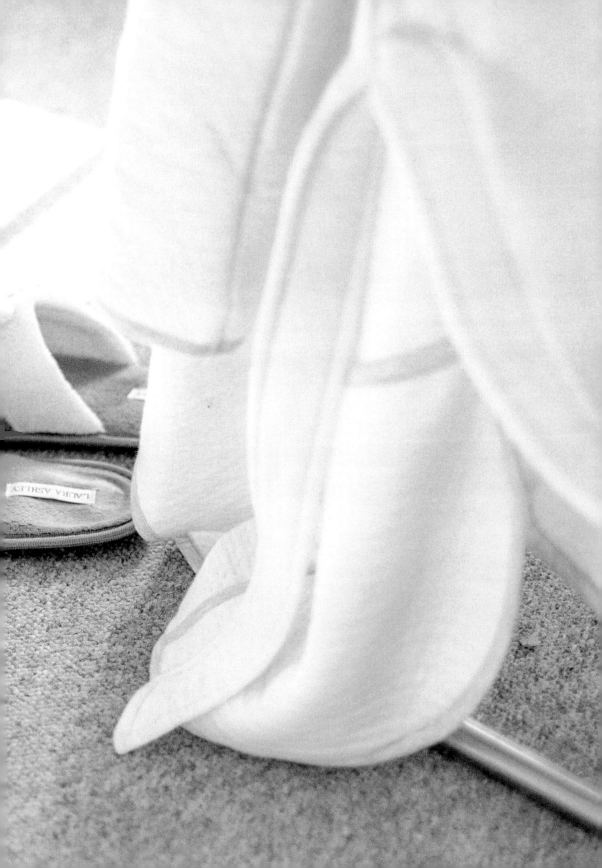

Simplistic White

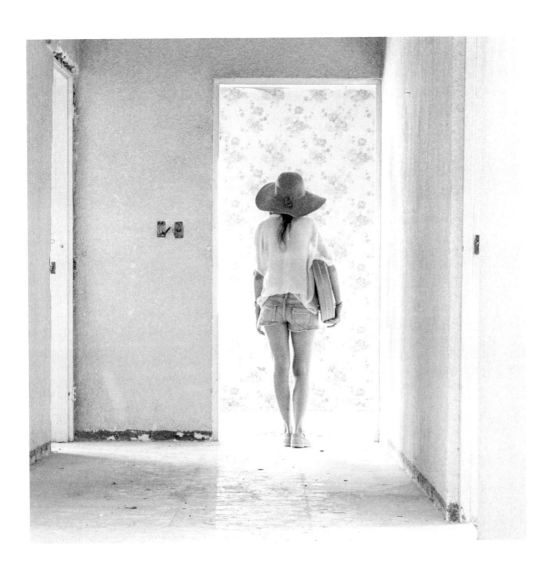

C3 M3 Y3 K0 C10 M0 Y10 K0

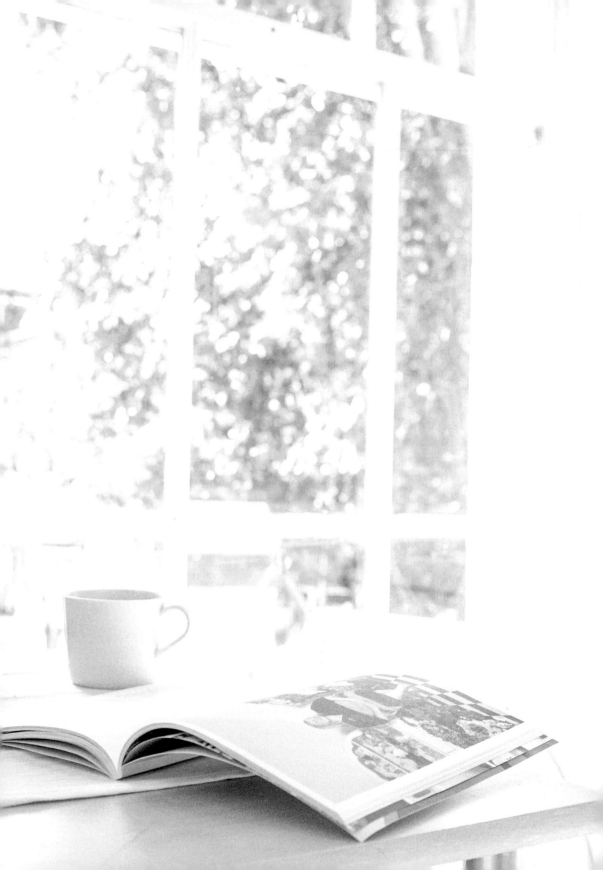

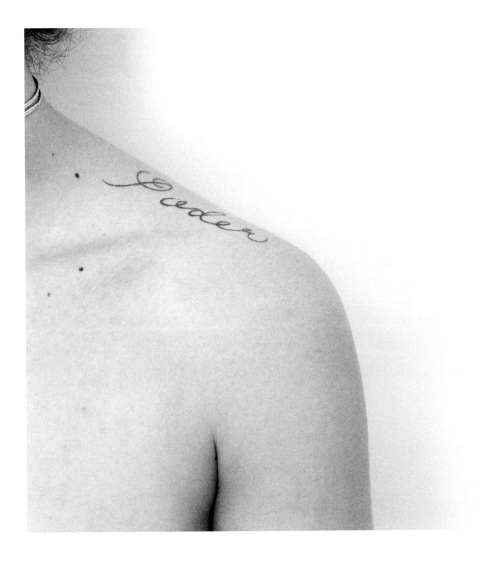

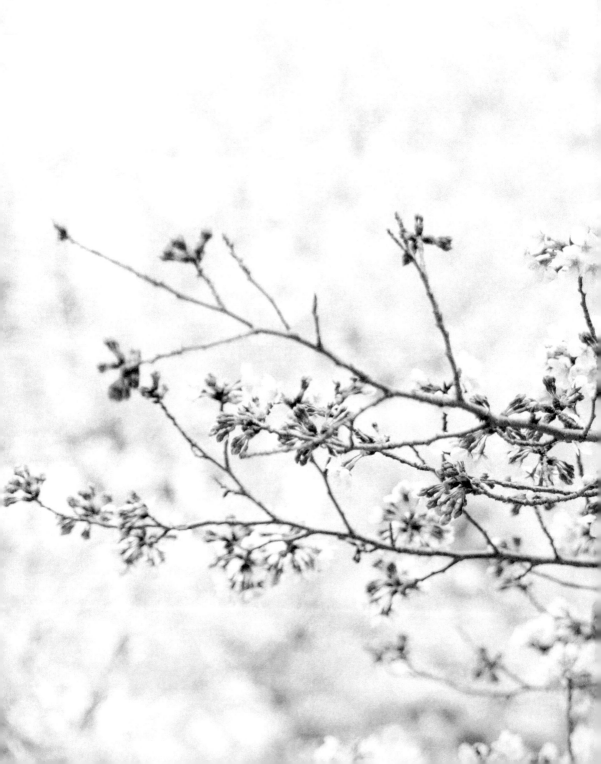

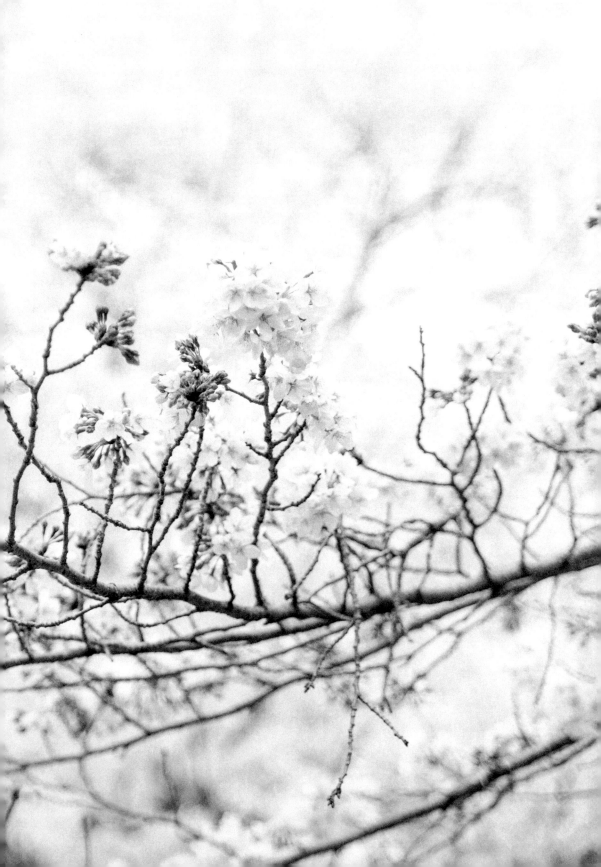

To O, your love and kindness have opened the eyes of my heart, and I learned to see life in a different way. To C, for patiently sharing your passion with me. To M, for always encouraging me to follow my dreams and never give up. To R, for exploring this amazing world by my side.

—

Marioly Vazquez

Simplistic White

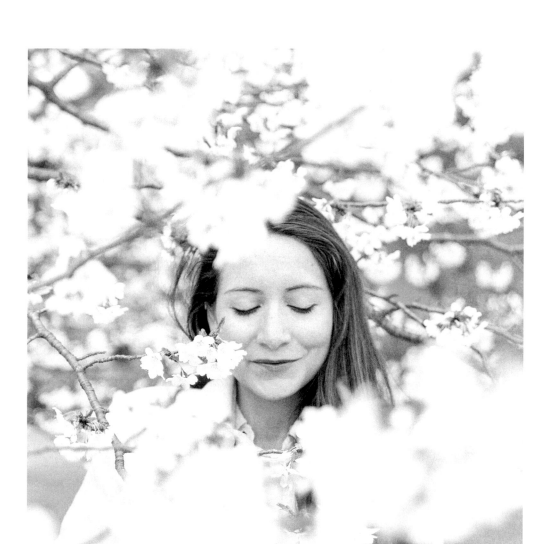

C2 M22 Y5 K0 C0 M0 Y0 K0

Pastel Moods

Published by New Heroes & Pioneers
Photography and text: Marioly Vazquez
Creative direction: Francois Le Bled
Book design: Daniel Zachrisson
Copy editing: Roxanne Sancto

Printed and bound by Lemon Print (Estonia)
Legal deposit December 2017
ISBN 97891-878-15-256

I want to thank all the people that have encouraged me throughout
this amazing journey of photography, and all those who have always
believed in me.

COLLECTIVE SHORTS
by NHP PUBLISHING